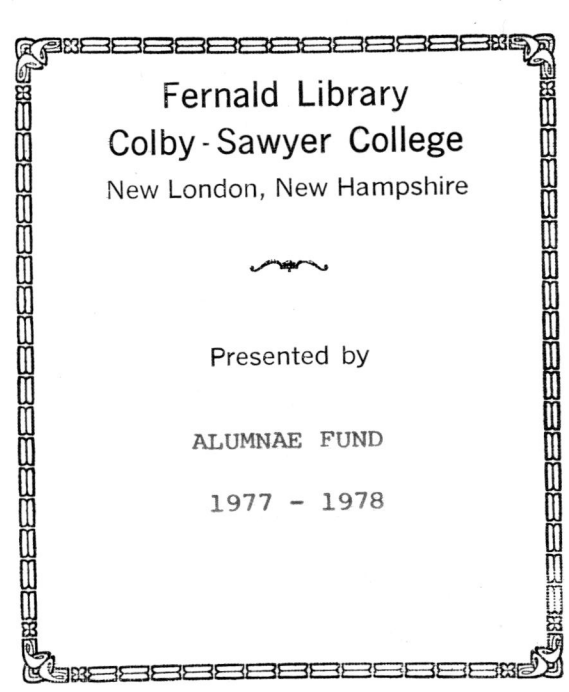

THE LIBRARY OF GREAT ART MOVEMENTS

# THE FAUVES

LIFT PICTURE FOR TITLE AND COMMENTARY

# THE
# FAUVES

*Gaston Diehl*

HARRY N. ABRAMS, INC., *Publishers*, NEW YORK

Nai Y. Chang, *Vice-President, Design and Production*
John L. Hochmann, *Executive Editor*
Margaret L. Kaplan, *Managing Editor*
Barbara Lyons, *Director, Photo Department, Rights and Reproductions*
Robin Fox, *Designer*

Library of Congress Cataloging in Publication Data

Diehl, Gaston.
  The fauves.

  (Library of great art movements)
  Bibliography: p.
  1. Fauvism—History.   2. Painting, Modern—20th
Century.   I. Title.
ND196.F3D5313      759.06      72-5650
ISBN 0-8109-0114-5

Library of Congress Catalogue Card Number: 72-5650
Published by Harry N. Abrams, Incorporated, New York, 1975

# CONTENTS

Acknowledgments     8

THE FAUVES   by Gaston Diehl     11

Drawings, Watercolors, and Prints     51

Chronology     65

Bibliography and Retrospective Group Exhibitions     163

Index     165

## COLORPLATES

RIK WOUTERS   Portrait of Mme Wouters (Lady in White)
*Musée National d'Art Moderne, Paris*     Frontispiece

PAUL GAUGUIN   The Day of the God (Mahana no Atua)   *The Art
Institute of Chicago*     69

ARMAND SÉGUIN   The Two Cottages   *Collection Samuel Josefowitz, Lausanne*     71

LOUIS VALTAT   Nude in a Garden   *Collection Dr. Jean Valtat, Paris*     73

LOUIS VALTAT   Algiers   *Collection Dr. Jean Valtat, Paris*     75

HENRI MATISSE   Notre Dame   *Collection Mr. and Mrs. Alexander M. Lewyt,
New York City*     77

HENRI MATISSE   Luxe, calme et volupté   *Private collection, Paris*     79

HENRI MATISSE   Open Window, Collioure   *Collection John Hay Whitney,
New York City*     81

HENRI MATISSE   Woman with a Hat   *Collection Mr. and Mrs. Walter A. Haas,* *San Francisco*   83

HENRI MATISSE   The Red Sideboard   *The Hermitage, Leningrad*   85

HENRI MATISSE   Music   *The Hermitage, Leningrad*   87

HENRI MATISSE   Joaquina   *National Gallery, Prague*   89

HENRI MANGUIN   Model Resting   *Collection Mme Lucie Martinais-Manguin,* *Paris*   91

HENRI MANGUIN   The Cork Oaks   *Collection Mme Lucie Martinais-Manguin,* *Paris*   93

HENRI MANGUIN   The Gypsy in the Studio   *Collection Mme Lucie* *Martinais-Manguin, Paris*   95

ALBERT MARQUET   The Pont Neuf in the Sun   *Boymans-van Beuningen* *Museum, Rotterdam*   97

ALBERT MARQUET   Sainte-Adresse   *Collection B. J. Fize, Paris*   99

MAURICE DE VLAMINCK   Under the Bridge at Chatou   *Perls Galleries,* *New York City*   101

MAURICE DE VLAMINCK   Reclining Nude   *Collection David Josefowitz,* *Geneva*   103

MAURICE DE VLAMINCK   Landscape near Chatou   *Stedelijk Museum,* *Amsterdam*   105

MAURICE DE VLAMINCK   Landscape at Chatou   *Collection Pierre Lévy,* *Troyes*   107

KEES VAN DONGEN   The Shirt   *Private collection, Paris*   109

KEES VAN DONGEN   Liverpool Night House   *Collection David Josefowitz,* *Geneva*   111

KEES VAN DONGEN   Nude   *Von der Heydt-Museum, Wuppertal*   113

RAOUL DUFY   The Posters at Trouville   *Musée National d'Art Moderne,* *Paris*   115

RAOUL DUFY   Street Hung with Flags at Le Havre   *Musée National d'Art Moderne,* *Paris*   117

RAOUL DUFY   Trouville   *Collection David Josefowitz, Geneva*   119

OTHON FRIESZ   Antwerp Harbor   *Musée des Beaux-Arts, Liège*   121

CHARLES CAMOIN   The Pont des Arts Seen from the Pont Neuf   *Collection* *Mme C. Camoin, Paris*   123

ANDRÉ DERAIN   The Dance   *Collection David Josefowitz, Geneva*   125

ANDRÉ DERAIN   Big Ben   *Collection Pierre Lévy, Troyes*   127

ANDRÉ DERAIN  London Bridge  *The Museum of Modern Art, New York City*  129

ANDRÉ DERAIN  Seascape  *Private collection, Brussels*  131

GEORGES BRAQUE  Landscape at L'Estaque  *Private collection, Paris*  133

GEORGES BRAQUE  Landscape at La Ciotat  *Private collection, Paris*  135

GEORGES BRAQUE  Landscape at La Ciotat  *Collection Mr. and Mrs. Leigh B. Block, Chicago*  137

MAURICE MARINOT  Interior  *Collection Pierre Lévy, Troyes*  139

BÉLA CZÓBEL  Man with a Straw Hat  *Collection R. Stanley Johnson, Chicago*  141

ROBERT DELAUNAY  Self-Portrait  *Musée National d'Art Moderne, Paris*  143

SONIA DELAUNAY-TERK  Philomène  *Collection the artist*  145

HANS PURRMANN  Factory Landscape in Corsica  *Wilhelm-Lehmbruck-Museum der Stadt, Duisburg*  147

KARL SCHMIDT-ROTTLUFF  The Doorway  *Collection Dr. E. Schneider, Düsseldorf*  149

ALEXEJ VON JAWLENSKY  House with Trees  *Wallraf-Richartz-Museum, Cologne*  151

WASSILY KANDINSKY  Landscape at Murnau  *Collection Gustav Zumsteg, Zurich*  153

FRANTIŠEK KUPKA  The Girl at Gallien  *National Gallery, Prague*  155

MATTHEW SMITH  Nude, Fitzroy Street, No. 2  *The Arts Council of Great Britain, London*  157

CUNO AMIET  Autumn Sun  *Kunstmuseum, Winterthur, Switzerland*  159

PIET MONDRIAN  Portrait  *Collection Hannema-De Stuers, Kasteel "Het Nyenhuis," Heino, The Netherlands*  161

# ACKNOWLEDGMENTS

I wish to express my warm gratitude to all those who have so generously assisted me in my research:

*foreign cultural attachés and advisers in Paris:* Gheorghe Baltac (Rumania), H. Bugge-Mahrt (Norway), Guy C. Buysse (Belgium), Sadi de Gorter (Netherlands), Frédéric Dubois and Charles Hummel (Switzerland), Marat Kharazian (U.S.S.R.), Lorenz von Numers (Finland), Gabor Pap (Hungary), Professor Giovanni della Pozza (Italy).

*abroad:* P. A. Ade, Director of the Haus der Kunst, Munich; Katarina Ambrozic, Curator of the National Museum, Belgrade; M. Bafcop, archivist-curator of the Musée-Centre Culturel, Mechelen; Barbu Brezianu, Director of Research at the Art History Institute, Bucharest; Mme Chartrain-Hebbelinck, Musée d'Art Moderne, Brussels; Dr. G. Händler, Director of the Wilhelm-Lehmbruck-Museum der Stadt, Duisburg; Luc Hasaerts, Brussels; Jiri Kotalik, Director of the National Gallery, Prague; Myron Laskin, Jr., and Joanna Marsden, The National Gallery of Canada, Ottawa; Marija Pusic, Curator of the Museum of Modern Art, Belgrade; Franco Russoli, Curator of the Brera Gallery, Milan; Dr. Laszlo Tarr, Editor-in-chief of the Corvina Press, Budapest; Gabriel White, The Arts Council of Great Britain, London; René Cheval and René Hombourger of the French Cultural Services in Germany.

*artists:* Béla Czóbel, Sonia Delaunay-Terk; also Mmes Camoin and Larionov.

*collectors:* B. J. Fize, R. Stanley Johnson, David and Samuel Josefowitz, Claude Laurens, Pierre Lévy, Mme Lucie Martinais-Manguin, Raymond Nacenta, Georges Pillement, Jacques Pignet, Dr. Jean Valtat, Georg Waechter Memorial Foundation.

*curators:* Jean Adhémar, Chief Curator, Print Room, Bibliothèque Nationale, Paris; Pierre Berjole, Curator, Musée de l'Annonciade, Saint-Tropez; Victor Beyer, Curator, Musée des Beaux-Arts, Strasbourg; Danielle Giraudy, Curator, Musée Cantini, Marseilles; Michel Hoog, Curator, Musée National d'Art Moderne, Paris; Mme Latour, Curator, Musées de Marseille; Mlle Martin-Mery, Curator, Musées de Bordeaux; Mlle Popovitch, Curator, Musées de Rouen; Claude Souviron, Curator, Musée des Beaux-Arts, Nantes; Mme G. Testanière, Curator, Nouveau Musée des Beaux-Arts, Le Havre.

*art galleries:* Galerie Charpentier, Galerie Maeght, Galerie de Paris, Galerie Denise Valtat.

# THE FAUVES

1. Henri Matisse. BLUE STILL LIFE. 1907. Oil on canvas, 35 × 45 3/4″. © *The Barnes Foundation, Merion, Pa.*

## A DEFINITION

Seen in itself, at the moment it happened, the event may seem rather insignificant, one more anecdotal incident destined for oblivion.

At the 1905 Salon d'Automne, held in the recently opened Grand Palais, a few young artists who have already gained recognition—Marquet, Manguin, Camoin—together with such newcomers as Derain, Vlaminck, Van Dongen—find their works assembled in one room around those of Matisse, considered to be the leader of the group. The striking unity of the canvases, with their heightened colors, creates a sensation and announces the birth of a new school. The public, however, bursts out laughing and thinks it is having its leg pulled. The worthy bourgeois of the day, it is true, are in the habit of going to the Salon des Indépendants and the Salon d'Automne to exchange jokes and sarcastic remarks about the new artists. The press follows suit, and a page of *L'Illustration* of November 4 reproduces several pictures in order to hold them up to ridicule, including in its condemnation such other painters as Valtat and Rouault, whose works are exhibited in the neighboring rooms.

Who could have taken these artists seriously in the middle of *la belle époque*, in a heedless and continually festive capital, where the newspapers were more concerned with the exploits of the queens of *tout Paris*—Caroline Otéro, Emilienne d'Alençon, Liane de Pougy, or Cléo de Mérode—than with the Kaiser's visit to Tangier or the promulgation of the law on the separation of Church and State? Even

11

and discussed feature of these exhibitions. Art galleries and collectors, particularly from abroad, take a growing interest, with the result that the Fauves finally obtain a certain recognition from the public and press despite the objections and reservations still being voiced even by such critics as Vauxcelles or Malpel, who stand by them and believe in their future.

Everything seems to revert to normal, however, by 1908. There is a general sigh of relief, but a short-lived one, since a new pictorial adventure has begun in the privacy of the studios—Cubism, which soon replaces Fauvism at the Kahnweiler Gallery. In the *Gil Blas* of March 20, Vauxcelles sadly remarks of the Salon des Indépendants: "Alas! The heroic period is over. Where are the days when the Independents, with their violent excesses, provoked the Homeric mirth of the bourgeoisie and the press? It's really sad." Yet he is the first to congratulate Friesz, still exhibiting among the Fauves, for having abandoned the path along which "he has been straying for the last two or three years," and for finally escaping "from his abstractions" to "join the true French tradition."

At the Salon d'Automne of the same year, the Fauve heresy seems to have subsided, with many of its adherents choosing to compromise or give up the struggle. The group has disappeared once and for all. Its former members are now scattered at random in the different rooms. Matisse finds himself in near isolation, presenting an impressive array of works and defining shortly thereafter—in *La Grande Revue* of December 25—the aesthetic principles that govern his art, it being understood that these principles, which he has every intention of following, are not binding on anyone but himself.

And so, scarcely born and after only three short years of development, Fauvism is ingloriously liquidated. Abandoned or disowned by most of its members, the group is totally disbanded. Nor was there any reason to believe at the time that the incident was not irrevocably closed.

If we ignore the future of these artists—and it is in fact better to forget what we know about their development, their changes of direction, the successes and failures that await them—their association seems fortuitous, destined to be short-lived, and their school all the more ephemeral, not to say artificial.

Unlike their predecessors the Impressionists and the Nabis, they never constituted a truly organized group in the Salons nor in the few galleries where their works were assembled as friendship and circumstances dictated. They did not hold common meetings, nor did they publish a manifesto like their German colleagues, who at the same time were founding Die Brücke.

Hence the rather hasty conclusion reached by certain critics and historians who refuse to admit the existence of a group and still less of a movement. In their eyes, Fauvism remains a simple fit of growing pains, a youthful elation

2. Charles Camoin. PORTRAIT OF ALBERT MARQUET. C. 1904. Oil on canvas, 36 1/4 × 28 3/4".
*Musée National d'Art Moderne, Paris*

the critic Louis Vauxcelles, a friend and defender of these artists, is disconcerted by their latest works and cannot resist making a witticism at their expense by dubbing them *fauves* (wild beasts) in his review in the October 17 issue of *Gil Blas*.

This ironical nickname will stick to them, whether they like it or not, for the rest of their careers. Yet under this flag their rather chance existence as a group, which they themselves never formally acknowledge, gains them notoriety and numbers, attracting such new recruits as Friesz, Dufy, and later Braque. In 1906 and 1907, at the Salon d'Automne and at the Salon des Indépendants as well, the "Fauves' den," as it is derisively called, tends to become the center of attraction and prestige, the most anticipated

that seized certain artists, spreading from one to another, until the inevitable moment when each had proved his powers sufficiently to be able to oppose the others.

No one can deny that the course of the history of art, particularly at the beginning of the twentieth century, is almost entirely governed by these strong personalities, who stand out against their period and indeed give it a new face. At rare intervals, however, there arise moments of convergence, of symbiosis, when the efforts of these artists combine and harmonize. The bold impulse that they generate becomes further strengthened and heightened, thereby attracting a wide following.

Fauvism fully deserves its exceptional place in the history of art, because it in fact constituted this unexpected crossroads, this influential meeting place, this privileged stage, and imparted to the period an unprecedented common impulse that corresponded to the diffused aspirations of the time. The movement represented a crucial involvement, a culminating phase for a whole generation. Matisse, his friends, his pupils or followers, and even succeeding generations, all constantly drew upon it as from a fountain of youth, making it "the inexhaustible source of limitless beginnings," to borrow Jean Cassou's excellent phrase. One might also quote the definition proposed by the same author in 1960: "In the final analysis, Fauvism must be considered not as a school, but as the moment when, in its continual progress from style to style, a fundamental tendency in the art of painting reached a high point of dazzling intensity."

This moment, which had such a deep influence on art and artists, is thus far more important than a brief and summary account would at first suggest. To establish its real significance beyond mere appearances, the Fauvist phenomenon must be investigated in detail and studied from the three following standpoints:

—its true position within the period and the diverse interpretations of that period that it provides;

—its actual development, bearing in mind the long gestation that had already brought these artists close to one another well before the birth of the movement in 1905;

—its unexpected, and so far seldom mentioned, continuation through the immediate or distant repercussions that it provoked in France as well as abroad.

IN RAPPORT WITH THE TIMES

A false picture, stemming from a Parisian bourgeois tradition of the beginning of the century, long fostered the belief that most modern artists lived on the fringes of society, totally cut off and even ostracized. A persistent and overpublicized legend had grown up about the widening gulf supposedly being formed between artists and

3. Henri Manguin. SELF-PORTRAIT. 1905.
Oil on canvas, 21 5/8 × 18 1/8".
*Collection Mme Lucile Martinais-Manguin, Paris*

society, and both parties had moreover ended by believing it themselves. The supporters of an obsolete academicism had welcomed it because it conveniently justified their systematic neglect of most of the Impressionists and of the great innovators who had died young, such as Seurat and Van Gogh. The artists, for their part, were quite prepared to take this opportunity to play the role of misunderstood outcasts from a society they despised.

Yet on the aesthetic level there were a number of indications of the deep changes in taste that were taking place. At the Universal Exposition of 1900, the centennial exhibition of French art could not refuse to admit the Impressionists. For some years now the Nabis had enjoyed an

5. André Derain. PORTRAIT OF VLAMINCK. 1905.
Oil on canvas, 16 1/8 × 13".
*Private collection, Paris*

4. Albert Marquet.
MATISSE PAINTING A NUDE IN MANGUIN'S STUDIO. 1904–5.
Oil on canvas, 39 3/8 × 28 3/4".
● *Musée National d'Art Moderne, Paris*

6. Henri Matisse. SELF-PORTRAIT. 1906.
Oil on canvas, 21 5/8 × 18 1/8".
*Statens Museum for Kunst, Copenhagen*

14

enviable position in the art world. Before long, posthumous recognition and respect for the initiators of modern art were to become widespread. Although the official Salon kept a part of its clientele and the support of the State and press, its position was nonetheless weakened both by the extension of the Salon des Indépendants, which attracted large numbers of exhibitors, and by the creation in 1903 of the Salon d'Automne, which received a favorable reception from the critics. The simultaneous increase in the number of art periodicals and galleries, and above all the international exchanges stimulated by the Salon d'Automne and by the foreign visitors who were beginning to flock to Paris, show that what was happening instead was a sudden broadening of understanding between the public and the artists, an effort at greater rapport.

A rapidly changing society was in fact discovering new needs, new objects of inquiry, a future rich in promise for which writers and artists were intuitively the spokesmen. Only a small part of this society, all the more vocal because it felt itself to be swimming against the tide, clung to the past and fought to preserve its outdated notions.

Although they opposed this overly conservative bourgeoisie, the masters of tomorrow, as their friends confidently called them, had no wish to escape the influence of the time by withdrawing into isolation. Indeed, they developed the most vital elements of the period and gave expression to its primary aspirations. For, as the late Pierre Francastel declared: "Man continues to create the imaginary space in which artists project a fascinating interpretation of his convictions and habits. Plastic space inevitably changes according to our common ascendancy over the external world; inevitably it reflects both our mathematical conception of the physical laws of matter and those values of sentiment that we should like to see triumph."

A survey of the most salient aspects of the period will show in what manner they provided the inspiration and setting for the works of the Fauves.

A spirit of such unshakable optimism was ushered in by the new century, despite its trials and crises, that it came to be known to posterity by the enviable name of *la belle époque*.

The premises were favorable. The Universal Exposition of 1900 was a great success, attracting many sovereigns and foreign visitors and bringing together East and West as the Exposition of 1889 had tried to do before. Although the pompous appearance of the monuments that it left behind —the Grand Palais, Petit Palais, and the Pont Alexandre III—reveals the self-confidence and prosperity of the time, their smiling composure remains highly conventional. The smile becomes more equivocal, more acid, in the growing number of satirical papers such as *Le Rire* and *L'Assiette au beurre*, which enjoyed unprecedented popularity.

Although they did not set themselves up as reformers or judges of society, our artists occasionally earned their living by contributing to these papers and are thus closely associated with the mixed and often contradictory trends that were beginning to emerge. In a confused way they express by turns the appetite for pleasure, the return to nature and even to the elemental, the critical examination and questioning of all accepted ideas, the determined pursuit of nonconformity, the feeling of brotherhood, the prevailing dynamism of the time—in other words, all the dominant elements of the period that we are considering.

There was a growing opposition to *fin-de-siècle* tastes, condemned as decadent, to Symbolism or Intimism with their refinements and affectations, confined atmosphere, and anxious or malevolent esotericism. As early as 1897, in *Les Nourritures terrestres*, André Gide glorified the Dionysiac spirit: "Pleasure! Let me repeat this word constantly; let it be a synonym of *well-being* and even, quite simply, of *being*." He extols the intensity of the moment, the beauty of light, gardens, and open windows; he sings the charms of the Maghreb regions and the desert; he ends with this proud and fervent profession of faith that will, along with the rest, be scrupulously followed by the Fauves: "Cleave only to those things in yourself which you feel exist nowhere outside yourself, and make of yourself, impatiently or patiently, the most unique of beings."

At the same time Saint-Georges de Bouhélier is publishing his *Chants de la vie ardente* (1902) and Verhaeren *Les Forces tumultueuses*. Colette, with Willy's help, begins the *Claudine* series, which is to celebrate man's ties with nature and animals, while Péguy, in the *Cahiers de la quinzaine*, examines the writer's mission in society. At Créteil, on the outskirts of Paris, the Abbaye group with Georges Duhamel, Charles Vildrac, Raymond Arcos, and Georges Chennevière assembles in a kind of commune, from 1904 to 1906, under the leadership of Jules Romains. In the name of the doctrine of Unanimism that he launches with his friends, Romains urges poets and men of letters to become the chief instruments in the soul's conquest of the universe, in man's exploration of reality, which he himself describes in impassioned terms: "My body is the tremor of the city. . . ."

Thus, among writers and more particularly within this last group, which was to recognize its affinities with the Fauve painters and constantly support their efforts, a marked change of attitude was strongly manifested in a thirst for life, an interest in everyday themes, the need for liberation and the external expression of instinctive forces, communion with nature and the masses, an imperative revision of values.

Philosophers and aestheticians were concerned with similar questions. From Freud to Croce, from Durkheim to Lévy-Brühl, they turned to the study of motivations and the deeper impulses, to the psychology of the individual and the community, and to the relations between them in order to evolve an increased mutual understanding.

It is interesting to note that this search for the foundations of society, pursued by philosophy throughout the millenniums, brings about an actual return to sources and origins in other areas, often casting doubt on long accepted values. Classical and traditional concepts were being breached on all sides by Evans's excavations at Knossos, which brought to light the archaic civilizations; by the rehabilitation of the French Primitives at the 1904 exhibition; by the growing interest in folklore, popular art, prehistory, and, before long, in the arts of so-called savages. In France and Germany, ethnographical museums began to attract artists. At the same time Strzygowski, in his *Orient ou Rome*, raises the question of making a choice, while Courajod in his lectures at the Ecole du Louvre, and Riegl in his writings both stress the importance of the art of primitive peoples.

A virulent anti-conformism spreads to all levels of a society which is undergoing rapid economic and industrial changes and rebelling against the teachings and inherited fetters of the past, including the now bitterly opposed tenets of religion. The desire for emancipation and conquest asserts itself triumphantly throughout the world. Despite unrest, the anarchist plots and increasing strikes, the recourse to violence urged by Georges Sorel, the series of wars in the Far East, the bloody insurrections in Saint Petersburg and Moscow, and the continual risk of conflict in Europe, an atmosphere of optimism persists. Everyone trusts in the future. Socialism partially imposes its views and succeeds in unifying itself. The Dreyfus case is at last reviewed. Above all, thanks to the fraternal élan that grips artists and writers from Steinlein to Romain Rolland, Péguy, and Gorky, the people recover their sense of strength and dignity.

In reality, human hopes are now focused predominantly on the machine, whose astonishing advances are daily accelerating the tempo of life. Its feverish round revolution-

7. Georges Braque. LE PORT D'ANVERS (ANTWERP HARBOR). 1906. Oil on canvas, 19 5/8 × 24".
*The National Gallery of Canada, Ottawa*

8. Kees van Dongen. SELF-PORTRAIT. 1905.
Oil on canvas, 21 5/8 × 15″.
*Private collection, Monaco*

10. Louis Valtat. WOMAN WITH A HAT. 1900.
Oil on canvas, 25 5/8 × 18 1/8″.
*Private collection, Paris*

9. André Derain. SELF-PORTRAIT. 1904–5.
Oil on canvas, 13 5/8 × 9 1/2″.
*Private collection, Paris*

izes Paris successively with the *Métro* in 1900, the Salon de l'Auto in 1901, the first buses in 1906, and the Salon de l'Aéronautique in 1908.

Enthralled by the power of this pervasive dynamism, our artists spontaneously decide to appropriate its effects in order to sublimate them. They make it the coordinating element for all the needs of the moment, all the problems that arise. By the same token, they use it as an individual means of protection, an instrument of liberation from the constraints of an increasingly rational organization of society.

They thus become the heralds and spokesmen of this jubilant, vital impulse, to which they give the necessary breadth and animation. Around them caricaturists and poster artists employ the same bright and even violent colors, the same vigorous and incisive lines, thereby preparing the public for a visual re-awakening that the painters will not fail to exploit.

# The Three Ages of Fauvism

## PRELUDE

At the start of nearly every movement there is a rallying point, a place where young students come into contact with each other, work together, and become friends. Thus, for preceding generations the Académie Suisse and the Atelier Gleyre had served as a meeting place for the future Impressionists, as did the Académie Julian for the Nabis. It may seem surprising that the Ecole des Beaux-Arts in Paris—sunk as it then was in mediocrity and reputedly a bastion of the worst academicism—should have played a similar role for some of the future Fauve painters, even to the point of exerting a lasting influence on them. To refurbish its tarnished reputation and to attract a younger generation indifferent to academic honors and the Prix de Rome required the providential presence of Gustave Moreau, one of the leading representatives of Symbolism and a liberal spirit who succeeded his friend Elie Delaunay as professor there at the age of sixty-six.

In the studio that he directed from January, 1892, until his death in April, 1898, he tried, with a rare eclecticism and a complete disregard for Salon fashions, to encourage his students in a thorough study of the old masters, whose works he urged them to copy in the Louvre, at the same time drawing their attention to such outstanding contemporaries as Cézanne, Degas, and Toulouse-Lautrec, and in the end leaving each free to follow his own temperament. His exhortations, couched in striking formulas, were to have lasting echoes: "The evocation of thought through arabesques and plastic means, such is my aim"—"The contained and measured work in its burning passion . . ."—"Nature in itself is nothing! It merely gives the artist an occasion to express himself. Art is the unflagging pursuit through plastic means of expression and inner feeling"—"One must think color, one must have it in the imagination."

11. Henri Manguin.
THE FOURTEENTH OF JULY AT SAINT-TROPEZ. 1905.
Oil on canvas, 24 × 19 5/8".
*Collection Mme Lucile Martinais-Manguin, Paris*

12. Albert Marquet. CARNIVAL AT LE HAVRE. 1906.
Oil on canvas, 25 5/8 × 31 7/8″.
*Musée des Beaux-Arts, Bordeaux*

13. Henri Matisse. VIEW FROM BELLE-ÎLE. C. 1897.
Oil on canvas, 18 1/8 × 15″.
*Musée des Beaux-Arts, Bordeaux*

Although he rarely showed his seductively manneristic canvases and still less his sketches and watercolors, executed with amazing freedom in a bold, splashing technique, he nevertheless attracted a following through his feeling for lavish colors and rich textures, his incisive draftsmanship, his taste for a fabulous East, his strong idealism, vast culture, and refinement. The encouragement, affection, and understanding that he lavished on his most gifted pupils explain his stimulating influence and the enthusiasm he inspired. As Roger Marx wrote in 1896: "The fires of insurrection have been lit in the very heart of the Ecole des Beaux-Arts; all the rebels against routine, all those who wish to develop in their own individual way, have gathered under the shield of Gustave Moreau."

Apart from his run-of-the-mill pupils (numbering more than eighty at the time of his death), a small nucleus consisting of former students or friends who had become almost disciples had emerged and met from time to time. It included Desvallières, Piot (admirer and self-appointed historiographer of Delacroix), and Rouault; such older habitués as Lehmann, the Belgian Evenepoel, Milcendeau, and Bussy; the newcomers who flocked in after 1895, Matisse and Marquet (who had met at the Ecole des Arts Décoratifs), Flandrin, Prat, Manguin, Linaret, the Rumanian Pallady; and the last recruits, Rouveyre and Camoin. A deep sense of comradeship united most of these young artists, all about the same age, who had generally worked and had their first exhibitions together in 1896 at the Salon de la Société Nationale des Beaux-Arts, in 1901 at the Salon des Indépendants, and in 1903 at the Salon d'Automne. The fact that in 1905 Vauxcelles could still recall "that cohort, cultivated to the point of Byzantinism, that formed around Moreau" shows how relatively united

their group remained over the years and through its various transformations.

Matisse, slightly older than the others, quickly assumed leadership. As early as 1896, during a summer stay at Belle-Ile and under the guidance of a friend of the Impressionists, the Australian painter John Russell, who offered him two drawings by Van Gogh, he discovered with a rapture that by his own admission astonished him "the brilliance of pure color" in a small seascape. The following year he repeated the experiment. His teacher could hardly disapprove of this trend, already being followed by Evenepoel and still more by Linaret. Aided by his new passion for Japanese textiles and by the advice of Pissarro, whom he had gone to consult together with Manguin, he completes his emancipation in solitude under the radiant sky of Corsica, where he spends the beginning of 1898. His disappointments at the Nationale, Moreau's death, and his quarrels with Cormon, who bars him from his studio, lead him to break definitively with the Ecole. Soon after, he draws Marquet into a brief Pointillist experiment, as can be seen from the latter's *Nu fauve* in the Bordeaux Museum. Before long the two friends, working together freely at Arcueil and the Luxembourg, and accompanied in the succeeding years by Manguin, Camoin, and a few

others, embark on what has been properly called "Pre-Fauvism" because of its joyful lyricism, its spirited, brilliantly colored brushwork, which the sun of Toulouse was to heighten still further in Matisse's paintings of 1899. Matisse was by now so firmly set on his course that on his return from the South of France and despite his limited means—his second child had just been born—he decided to buy two small canvases that he had seen briefly at Vollard's, a Cézanne and a Gauguin, and these were to serve him from then on as models.

The budding group that was later to be christened the Fauves acquired additional followers in 1898 in a second establishment attended by Matisse.

Anxious to work more from the human figure—he now took up sculpture and followed evening classes in the Rue Etienne Marcel—Matisse, wishing to avail himself of a live model and engrossed as always by the play of values, enrolled in a small private academy recently opened by a certain Camillo in the Rue de Rennes, where Eugène Carrière was a teacher. Cordiality and mutual respect grew up between the self-styled student and the kindly old teacher, who refrained from commenting on Matisse's powerfully expressive nudes, their bold ultramarine volumes heightened by the violently contrasting oranges and pinks that satisfied Matisse's new passion for constructing his pictures exclusively with color. The results, which Matisse justified by extolling Cézanne, soon earned him a following among his comrades, most of them his juniors: Biette, Laprade, Derain, Chabaud, the Norwegian Karsten, and Migonney, who was shortly joined by his friend Jean Puy. In Puy's words, the group found in him "the inspiring element that arouses one's spirit." He communicated his enthusiasm to everybody, "the flame of his passion pro-pelled them toward the goal to which they ardently aspired." It was from their ranks that he was to recruit some of his new and most faithful associates, notably Puy and Derain. When the school closed its doors, they continued to meet occasionally at Biette's, but more often in Manguin's new studio in the Rue Boursault.

Although he did not remain aloof, Marquet rarely went to the Rue de Rennes. With Camoin, who soon left to do his military service, he preferred to mix with the crowd and make sketches from life. For a part of the year 1900, however, he earned his living by working daily with Matisse in the studio of the decorator Jambon. Sometimes the two friends would spend an evening in a cabaret—the sketches they made were shown at the Indépendants in 1901. That year Marquet spent the summer in Normandy with Manguin.

Thus, through these shared interests, these frequent meetings, which must surely have promoted an enthusiastic exchange of ideas, ever closer ties are forged among them. One after another they join the Indépendants—Manguin in 1902, Camoin and Puy in 1903, and so on, as well as the Salon d'Automne, where in 1904 Camoin and Manguin are reunited with Matisse and Marquet, who had already been invited in 1903. They form an even tighter group in the small gallery opened by Berthe Weill in December, 1901, in the Rue Victor Massé, where she judiciously alternates the works of young painters with those of the celebrated draftsmen of the period: Abel Faivre, Cappiello, Sem, Willette, Léandre, Forain, Chéret, Steinlein, Helleu, and such of their followers as Rouveyre and Villon. Beginning in February, 1902, she shows Marquet, Matisse, and his neighbors from the Quai Saint-Michel—Flandrin and Mme Marval. She also welcomes Girieud, Maillol, and Milcen-

14. Georges Braque.
LANDSCAPE AT L'ESTAQUE. 1906.
Oil on canvas, 23 5/8 × 28 1/4".
*Private collection, Paris*

15. Auguste Chabaud.
TWO PASSERS-BY ON THE ROAD. C. 1905.
Oil on canvas, 9 1/2 × 13″.
*Private collection, Paris*

deau, and becomes an early promoter of Picasso and Dufy. She holds a series of fragmentary showings, but it is only in April, 1904, that the group finally appears in a well-defined form, consisting of Camoin, Manguin, Marquet, Matisse, and Puy, to be immediately noticed by the critic Roger Marx, who stresses their "common desire for significance, which they strive to achieve through plastic means carried to the highest point of power and seductiveness." They finally have the satisfaction of seeing their patient efforts rewarded, since collectors now begin to show an interest in their works. In June Vollard organizes in his gallery a show of forty-six paintings by Matisse, and the State, as Michel Hoog records, buys works by Camoin, Marquet, and Matisse at the Salon d'Automne in 1904 and also at the Indépendants in 1905.

An outside circumstance helped to accelerate these developments. Invited to spend the summer of 1904 at Saint-Tropez with Signac and his Neo-Impressionist friends, Matisse was converted to their pictorial doctrine, which on his return he made a sincere effort to apply, particularly in his important work *Luxe, calme et volupté* (colorplate p. 79) executed during the winter and exhibited at the Indépendants in 1905, where its severity and rich harmonies caused a sensation. Under its influence, and no doubt still more under that of the great Seurat retrospective held that year at the Indépendants, several of Matisse's friends hastened in their turn to Saint-Tropez. As the critic Vauxcelles wrote: "In the spring of 1905 there was a valiant little colony of artists painting and conversing in this enchanted land—Signac, Cross, Manguin, Camoin, Marquet."

The new vogue spread rapidly. Even such painters as Van Dongen and Vlaminck, who up to now had remained slightly aloof, did not hesitate to use gay, kaleidoscopic splashes of color in most of the works that they exhibited —Vlaminck for the first time—at the Indépendants in 1905. From different backgrounds and living somewhat on the margins of the group, Van Dongen in the Impasse Girardon in Montmartre and Vlaminck in Chatou—where after June, 1900, he had close ties with Derain—they are typical representatives of a northern atavism that draws its resources primarily from the force of instinct, in the manner of Van Gogh, who became Vlaminck's "god" when he was first revealed to him in 1901 at the Bernheim Gallery and later the same year at the Indépendants. Despite their definite vocation, their course had so far remained rather uncertain, although for his show at Vollard's in November, 1904, Van Dongen had been able to muster a hundred or so paintings that still showed restraint, as well as a few dynamically explosive watercolors.

The stage was therefore set when in 1905 the protagonists assembled at the Salon des Indépendants in a sort of dress rehearsal before their impending historical debut. Even Derain was present, returning from his three years of military service to take up painting with Vlaminck again on the banks of the Seine, in the makeshift studio that they shared on the Ile de Chatou not far from the Fournaise restaurant, that favorite haunt of the Impressionists.

Vauxcelles is so well aware of what the artists are preparing half secretly in their studios or in their minds that some time before the opening of the Indépendants he announces "the audacities and extravagances . . . of some passionate young artists . . . who honor Cézanne as one of their masters, or rather one of their initiators, on a par with Gauguin, Van Gogh, and Monet. . . ." In his review, published March 23 in *Gil Blas* on the eve of the Salon opening, he criticizes Matisse's incursion into Pointillism while nevertheless recognizing his talent and the impor-

17. Henri Manguin. PORTRAIT OF JEAN PUY. 1905.
Oil on canvas, 31 7/8 × 25 5/8″.
*Collection Mme Lucile Martinais-Manguin, Paris*

16. Jean Puy. LANDSCAPE. 1904. Oil on canvas, 37 × 29 1/2″.
*Musée des Beaux-Arts, Rouen*

tance of his role: "This young painter . . . assumes, whether or not he wishes to, the position of head of the school; his friends Manguin, Camoin . . . Puy, impressed by his vigor, sometimes give a brutal turn to their senior's direct energy."

There can be no doubt that this Salon, considered "tumultuous" even by its champion Vauxcelles, met with the usual antagonism from the public and press. Yet this was followed by a certain shift of opinion in its favor. The newspaper *Le Temps* notes the conciliatory attitude of the new Director of Fine Arts, Dujardin-Beaumetz: "He had declared himself determined to encourage young artists. He is scrupulously keeping his promise. . . . He has opened a number of those exhibitions . . . which the Administration of the Fine Arts . . . made it its strict duty to ignore. Yesterday, for example . . . he was studying with obvious interest the Salon des Indépendants, which today is a center for the works of young artists." For the first time, in fact, the State was to make purchases at this Salon, buying twenty-three works.

Berthe Weill makes a similar observation in her mem-

oirs: "The Salon des Indépendants will certainly start a progressive movement toward *young painting;* the interesting Seurat and Van Gogh retrospectives can effectively silence the most recalcitrant. . . . The artists are very enthusiastic."

It remained for Matisse, however, to take the final step in the course of the summer and give a decisive turn to this converging movement. During the several months that he spent in the little port of Collioure, he was led to modify his ideas fundamentally under the combined influence of the warm Mediterranean sky and the strong contrasts in color of the Catalan landscape, the encouragement given by Maillol, the stimulating company of Derain, who had come to join him, and above all his delighted contemplation of the many Gauguin masterpieces kept by Daniel de Monfreid in his house at Saint-Clément. Gradually abandoning the dilutions of Pointillism, he imparts a new vigor to his touch, carrying color to its saturation point and adopting broad flat areas and bold outlines in a series of paintings—including *Open Window, Collioure* (colorplate p. 81)—which he was to continue on his return to Paris with *Wo-*

18. Albert Marquet.
THE LUXEMBOURG GARDENS. 1902.
Oil on canvas, 18 1/8 × 21 5/8".
*Musée des Beaux-Arts,*
*Bordeaux*

19. Charles Camoin.
PORT OF MARSEILLES. 1904.
Oil on canvas, 23 5/8 × 31 7/8".
*Nouveau Musée des Beaux-Arts,*
*Le Havre.*
*Gift of Auguste Marande, 1936*

20. Albert Marquet.
MADAME MATISSE
DOING NEEDLEWORK. 1905.
Oil on canvas, 25 5/8 × 31 7/8″.
*Private collection, Paris*

21. Charles Camoin.
MADAME MATISSE
DOING NEEDLEWORK. 1905.
Oil on canvas, 25 5/8 × 31 7/8″.
*Musée des Beaux-Arts, Strasbourg*

22. André Derain. WOMAN WITH SHAWL. 1905.
Oil on canvas, 31 1/2 × 25 5/8".
*Collection B. J. Fize, Paris*

*man with a Hat* (colorplate p. 83) and *Portrait with a Green Line* (Royal Museum of Fine Arts, Copenhagen), and some of which were to be exhibited at the Salon d'Automne in 1905. Derain, likewise intoxicated with light and in the grip of an elation that banished hesitation, followed suit to the best of his ability.

It would appear that this need to intensify brushwork and transform color was sufficiently felt by everyone, for when they met in October—those from Collioure, those from Saint-Tropez, and the rest—all showed a more or less similar development. Room VII at the Salon d'Automne had been reserved for them, one of the main central rooms, and here the works of Matisse, Derain, Vlaminck, Czóbel, Girieud, Manguin, Marquet, Camoin, and Van Dongen were hung side by side. But the public and the press inevitably connected them with the rather similar works scattered in the neighboring rooms: those of Puy in Room III; of Valtat, whose experiments had preceded those of his companions, in Room XV; even of Rouault in Room XVI, Marinot, and others. Vauxcelles is the first to be struck by this violently expressed unanimity, and he

describes Room VII as the "room of the daring extremists," whose merits he appreciates and whose progress he stresses. His article in *Gil Blas*, however, begins by denouncing the "decorative simplifications of Gauguin that haunt young brains to the point of obsession," and he cannot resist a final quip in mentioning the sculptures by Marque exhibited in the center of the room: "The candor of these busts is surprising in the midst of such an orgy of pure tones: Donatello among the *fauves*."

The joke immediately made the rounds of Paris and spread abroad. Informed people realized that an event of capital importance had just taken place. They discovered that a whole generation, after years of struggle, was triumphantly asserting itself.

MATURITY

Certainly no one was more surprised than the Fauves themselves, both by the scandal that they had unintentionally caused and their sudden and long-awaited success with dealers and collectors.

At the end of October Berthe Weill opened a group show of her faithful exhibitors, who now included Derain and Vlaminck. As she remarked: "The group, with these additions, has suddenly become much sought after; the Fauves are beginning to domesticate the connoisseurs." She also takes note of the interest shown by Guillaume Apollinaire.

There was a similar group show a little later at the Prath & Magnier Gallery, of which Léon Rosenthal wrote: "There is a gathering of avant-garde painters, masters of the intense touch and bold colors, the heroes of the Salon d'Automne, Manguin, Marquet, Matisse, Camoin, Van Dongen, Girieud. . . . Perhaps the time has come to . . . extol the harmony of pure tones and the glory of undiluted color. . . ."

Vollard, who had long had a contract with Valtat, immediately signed up Derain and Puy, and the following year Vlaminck.

Druet for his part had taken on Marquet, and in November, 1905, he held a Van Dongen show in the gallery he had opened at the beginning of the year. In March, 1906, he mounted a large exhibition for Matisse, whose works were beginning to be highly esteemed by French, American, and, before long, Russian collectors.

The Salon des Indépendants of 1906 confirms the general triumph. At the sight of the 5,552 works assembled, Vauxcelles exclaims: "Today the battle is won." Apropos of Room VI, which he calls the "Salon Carré of the young school," he does not hesitate to declare: "It contains a collection of artists several of whom will achieve fame and fortune . . . Marquet . . . Manguin . . . Puy . . . Vlaminck . . . Van Dongen . . . and Munch," whom he judiciously includes in the movement that was so indebted to him.

23. Maurice de Vlaminck. THE BRIDGE AT CHATOU. 1905–6.
Oil on canvas.
*Musée de l'Annonciade, Saint-Tropez*

24. Henri Matisse.
MADAME MATISSE OR THE JAPANESE WOMAN
AT THE SEASHORE. 1905.
Oil on canvas.
*Collection Philip Lilienthal, San Francisco*

The center of attention, however, is one vast canvas by Matisse, *Joy of Life* (fig. 25), which has been placed in Room VI along with the paintings of Derain and Czóbel. The stir penetrates to the heart of the Salon committee, and extends as far as Montmartre. Rejected by many, including Vauxcelles, who nevertheless concedes that it "conveys a feeling of refreshing joy," this flamboyant profession of faith, with its powerful and orchestrated rhythms in which Matisse acknowledges his particular debts to Gauguin and foreshadows his own whole future development, puts the seal on his prestige as leader. His following was soon to be enlarged by three friends from Le Havre— Friesz, Dufy, and Braque—already well represented at the Salon, the first two as early as 1903. Friesz was later to work beside Matisse when the latter installed himself in the deconsecrated convent of the Sacred Heart on the Boulevard des Invalides; during the summer of 1906, he accompanies Braque to Antwerp. Dufy, an admirer of Matisse and an old friend of Marquet, was to spend the summer painting the same scenes with the latter at Trouville, Sainte-Adresse, and Le Havre, as his friends had done the year before, taking Mme Matisse along as a model.

Scattered in different places, Matisse at Biskra and then again at Collioure, Derain at L'Estaque between two visits to London, Manguin at Saint-Tropez, where he chose to spend a large part of the year, Camoin at Marseilles, Vlaminck faithful to the banks of the Seine, Van Dongen living in the Bateau Lavoir, they nevertheless all prepare enthusiastically for the opening of the new season in October, which, as they know, will be a decisive occasion for them.

In the hostile opinion of the critic Camille Mauclair, published in *Art et décoration*, the organizers of the Salon d'Automne had been careful this time not to "appear to present as the most interesting and the most worthy of critical attention, as they did last year . . . those dozen or so artists . . . with their pretentious, ignorant, and clownish works. . . ." They had been confined to a single room in order that they "no longer bring discredit on the talent of their more serious and sincere colleagues."

With the exception of Puy, faithful to Cézanne, in Room VI, Valtat, whose painting was nonetheless considered violent, in Room XVI, and Braque, who had not submitted anything, all the Fauves were indeed assembled in Room III. The effect was all the more striking because the important Gauguin retrospective of 227 works was on display almost next door. The Fauves, united and almost fully represented, here reach their peak. For once Vauxcelles has nothing but unreserved praise for "this blinding room where pure colors sing at the top of their lungs," as he describes the "fireworks" set off by these *enfants terribles de la maison.*" The collection as a whole struck him as "gay, young, ardent," and all found some favor in his eyes: Matisse, Manguin, Marquet, Derain, Vlaminck,

25. Henri Matisse. JOY OF LIFE. 1906–7. Oil on canvas, 68 1/2 × 93 3/4". © *The Barnes Foundation, Merion, Pa.*

Czóbel, Van Dongen, Girieud, and Friesz, whom he congratulates on having "deliberately enrolled under this banner." Only Dufy was not mentioned, but the critic Paul Jamot, in *Gazette des beaux-arts*, points out his contribution to the group and "the liveliness of his renderings of sunlit crowds." Dufy, moreover, was having a large show at Berthe Weill's. She had decided to hold two annual exhibitions of the Fauve group, in March and November.

The year 1907 was to be for all the Fauves the year of their greatest development and the crowning of their success both in the Salons and the galleries, which vied with each other for the honor of exhibiting their works: Marquet and later Friesz at the Druet Gallery, Camoin and Van Dongen in Kahnweiler's shop in the Rue Vignon, which also bought from Derain and Friesz. The Blot Gallery organized a group show. The writer Elie Faure had been urging them for some time to collaborate in the decoration of the charity hospital, but unfortunately the project came to nothing.

And they remain the center of interest, the essential element in every discussion, despite the fact that they are split up in the Salons, divided alphabetically at the Indépendants, and dispersed also at the Salon d'Automne, Marquet in Room XV, Valtat in Room XVI, Manguin and Camoin placed with Duchamp-Villon in Room XVII, while the main body of the group, in which Braque is now finally included after the Indépendants, is assembled in Room XVIII.

Having championed them so far, Vauxcelles begins to be uneasy at the growing audience they attract, the authority they acquire, and the example that they set. In his review in *Gil Blas* on March 20, 1907, he passes to the attack with an ironical classification: "Matisse Fauve-in-chief, Derain deputy Fauve-in-chief, Friesz and Dufy adjutant Fauves, Girieud the irresolute Fauve . . . Czóbel the boorish Fauve, Bereny the apprentice Fauve, Delaunay the Fauvelet." He accuses Dujardin-Beaumetz, the Director of Fine Arts, of having "tried to domesticate the Fauves by giving them official recognition." He openly protests that "a movement that I consider dangerous (despite the strong sympathy

that I feel for its leaders) is forming among a small group of young artists. A chapel has been set up where two imperious priests, Derain and Matisse, officiate; a small band of innocent catechumens has there received baptism. The dogma consists in an uncertain schematism, which in the name of some obscure pictorial abstraction bans all relief and volume. I find little to attract me in this new religion."

In September he rejoices that the Salon d'Automne has ceased "to favor only the Fauves" by scattering them in different rooms, and attacks Matisse for "his uncouthness as a draftsman . . . his disregard for form," accusing him of "being a theoretician rather than a painter." He also blames the "highly gifted" Friesz for "having thrown himself headlong into the abyss," and suspects Vlaminck of wanting to "defect." In *Gazette des beaux-arts*, André Pératté discusses the "painters of today and tomorrow who declare themselves followers of Gauguin and Cézanne." While congratulating Manguin and Camoin for having "abandoned arbitrary distortions in favor of classical simplicity," he is inclined to show indulgence toward what he calls "the excesses of the rabid Cézannists, of whom Matisse is the standard bearer," and praises André Métthey for having enlisted the collaboration of the group for his experiments in painted ceramics, exhibited at the same Salon d'Automne.

What is the situation at the end of this year in which Fauvism has definitively taken shape, attracted widespread general attention, and gained a strong influence in France as well as abroad?

Vauxcelles's fears are far from unjustified. In two years a new pictorial language has been introduced and propagated, and now acquires for many artists the force of law and habit. Based on spontaneous transposition and the exaltation of direct emotion, on the possibilities of expression through color contrasts, linear elements, rhythm and surface combinations, this language above all seeks intensity, impact, cursiveness, and simplification. This conception necessarily implies abandoning traditional conventions regarding subject and object, relief, chiaroscuro, and effects of perspective; it requires a complete transformation of one's notions of space and time. In reality it confines painting to an experiment in two dimensions, but one where the bold equivalents of light, the orchestration of color values, the plastic organization of the composition all combine to satisfy the needs of expression and to recreate depth and space in other dimensions that suggest a continuous unfolding in time. Accentuated and harmonized by the economy of means used, the pure intensity of the moment is deepened and prolonged in a joyous outburst, in radiant delight.

No preconceived system prevails, however, among these artists; no method is dogmatically applied. The artists remain highly individualistic despite their common practice of treating the same subject, and their experiments run parallel. If in the beginning pure color had often played a decisive role as a dynamic factor and catalyzer, its use in flat areas, broad expanses, bold brushstrokes, and light washes remains extremely diversified, and as early as 1906 Matisse and Derain venture to use half-tones, shades of gray and ocher. They also exploit the resources of drafts-

26. Othon Friesz. LANDSCAPE. 1906.
Oil on canvas, 13 × 16 1/8".
*Private collection, Switzerland*

27. Raoul Dufy. COUNTRY FESTIVAL. 1906.
Oil on canvas, 18 1/8 × 21 5/8″.
*Private collection, Paris*

28. André Derain. L'ESTAQUE. 1906.
Oil on canvas, 50 3/8 × 76 3/4″.
*Private collection, Paris*

29. Maurice de Vlaminck. THE RED TREES. 1906.
Oil on canvas, 25 5/8 × 31 7/8″.
*Musée National d'Art Moderne, Paris*

manship in an infinite variety of ways: marked contours, arabesques, allusive or decorative symbols, and subjective distortions.

Before long each painter reveals his particular commitment: Valtat an eloquent fervor, Marquet concision, Vlaminck and Van Dongen the violence of impulse, Camoin and Puy a desire for moderation, Czóbel an expansive lyricism, Friesz a tendency to the baroque, Dufy a vibrant exuberance, Braque a refined taste, Derain and Matisse the need for order. In *La Phalange* of December, 1907, Apollinaire gives an extraordinarily penetrating analysis of Matisse's work, isolating first of all his typically French artistic qualities: "his forceful simplicity and gentle lucidity." He praises him for "confidently following his triumphant instinct," and clearly discerns that "the nature of his art is to be reasonable." Finally, he affirms that if Matisse has "assumed the stature and confident pride that distinguish him," it is because, while pursuing his interest in the art of every race, he has remained faithful to the European heritage.

This judgment may seem overly subtle and irrelevant, but is actually quite just, and no doubt explains why, in the years that followed, Fauvism, particularly in the person of Matisse, continued to exert such a powerful attraction and undiminished authority throughout Europe, while in its country of origin its disappearance was soon to be officially recorded.

DENOUEMENT

As we have already seen, the story of the Fauves draws to a rapid close during the year 1908. The final act seems to play itself out unbeknown to the protagonists, which only shows that they feel free to develop as they like, unhindered by doctrines. They continue moreover to meet, work together, and participate in the same shows.

In 1907, Marquet, Camoin, and Friesz had gone together to London, and Braque and Friesz had spent the summer at La Ciotat—in 1908, Derain and Vlaminck paint side by side at Les Martigues during the summer, while Friesz and Dufy travel to Munich. The following year, Manguin and Marquet visit Naples, and Matisse and Marquet go to Munich with Purrmann. They all gather once more at the biannual show at Berthe Weill's, who at Matisse's request holds a Czóbel exhibition in 1908, while Bernheim-Jeune shows the work of Van Dongen. The provinces have begun to take an interest in Fauvism, which occupies the limelight at Le Havre in June, 1908, at the Cercle de l'Art Moderne, in a general presentation introduced by Apollinaire, and again in Toulouse, where Charles Malpel organizes successive exhibitions on the premises of *Le Télégramme* and *L'Union artistique*.

The group, however, was already on the point of dis-

banding. Several, like Marquet, Camoin, and particularly Puy, have grown tired of the prolonged tension, and for some time have shown a desire to escape from this state of paroxysm, which clearly does not suit them, in order to return to more traditional painting. Several others, headed by Friesz and soon to be followed by Derain, Dufy, and even Vlaminck—not to mention Braque, now frankly in opposition—seem to have lost their confidence, and in their indecision take their inspiration from Cézanne.

This spectacular resurgence of the old Aix master after his death in 1906 is readily explainable. His prestige and influence had grown steadily among the new generation, according to the conclusions of the inquiry conducted in its midst and published in *Le Mercure de France* by Charles Morice, himself more a partisan of Gauguin. The articles published after Cézanne's death, and the twin retrospectives in 1907 at the Bernheim Gallery and at the Salon d'Automne, revealed to everybody the importance of his work, which had so far remained rather inaccessible. Bathers and still lifes immediately came back into fashion, and Matisse was not afraid to go along by paying homage to the artist whom he always called "the god of painting."

For many this was to be the occasion to put themselves in order, to resist the magic of pure color, now branded dangerous and a dead end, and to undergo a cure of austerity and constructive discipline. Thus the ground was prepared for Cubism. Almost a year before its public appearance on the scene at the Braque exhibition at Kahnweiler's in November, 1908, Cubism had revealed itself forcefully in Picasso's *Demoiselles d'Avignon*. It had been widely discussed in the studios and especially in the Stein drawing room in the Rue de Fleurus, where Picasso and Matisse amicably but firmly confronted each other.

A new page is being turned. As we have seen, Vauxcelles is so well aware of this that, at the time of the 1908 Indépendants, he ridicules "the schematizers . . . who want to create an abstract art," and faced with Braque's canvases he admits: "I am completely out of my depth. This is Kanaka art, willfully and aggressively unintelligible." The whole of this Salon, despite its array of 6,700 works, disappoints him and sounds the death knell of many hopes. The excitement of the previous years is spent. The public lacks curiosity and the artists enthusiasm. For the first time Matisse has submitted nothing, nor has Derain, and their friends have dispersed in all directions. In Room VII, which Vauxcelles still calls "the Fauves' den" by way of final farewell, he notes that all except Van Dongen have "fled." He no longer thinks to use the expression, except to recall a vanished past, in mentioning the Salon d'Automne of the same year.

No more special rooms, no more group aspirations— the divergences grow more marked, and everyone again falls into line. The whole movement has broken up or disappeared. Ironically enough, the organizers have tried to

30. Kees van Dongen. THE CLOWN. 1906. Oil on panel, 29 1/8 × 23 5/8".
*Collection Mme Lucile Martinais-Manguin, Paris*

31. Othon Friesz. PORTRAIT OF FERNAND FLEURET. C. 1907.
Oil on canvas, 28 3/4 × 23 5/8".
*Musée National d'Art Moderne, Paris*

make strange juxtapositions, as Vauxcelles observes: the Cézannian austerity of Derain's bathers and cypresses beside a society portraitist in Room XII, or Vallotton in Room XVI opposite Matisse accompanied by Van Dongen and Camoin. The dispersal is complete. Manguin hangs in Room III, Puy and Vlaminck in Room VI, Friesz and Valtat in Room XVII. Braque and Dufy are absent and Marquet is represented only by drawings.

Fragmented and divided, Fauvism is now nothing but a vanishing ghost. The critics, however, continue out of habit to group together friends who are now separated by the Salon organizers or by their individual tendencies. In *Gazette des beaux-arts* Pierre Hepp concludes his article by declaring that a "family resemblance" still exists among Matisse, Friesz, Derain, Vlaminck, and Van Dongen, who "all have fire," and stresses that this "blaze of hope warms the Salon d'Automne and creates a center of energy there."

Malpel writes similarly about the Indépendants of 1909, that "Van Dongen, Matisse, Valtat, Friesz, Marquet, Dufy, Manguin reign here." Yet their works, which meet with increasing opposition, are scattered as usual throughout the relatively empty rooms—there were only 1,700 entries!—and beside them hang those of such painters as Léger, Metzinger, Herbin, and Lhote, who within two years, as their official successors, will constitute the Cubist group.

# Life and Survival of the Myth

With the more accurate perception that comes with time, we are today in a better position to evaluate a phenomenon that so far has hardly been taken into account, no doubt because it was found too difficult to explain. Just when the Fauve group, seemingly moribund, is breaking up and disappearing as such from the Salons, it recovers its strength elsewhere, gaining in France, and still more abroad, an immense range of influence scarcely to be compared with what preceded or followed it.

There are various reasons for this reversal. First of all, Fauvism, at the time of its appearance, aroused a lively interest in Parisian circles, many artists taking up its cause even if later they rejected it completely. Secondly, Matisse rapidly established a personal reputation which enabled him, through his work, his writings, and especially his Academy, to exert an influence that soon spread beyond the confines of France.

Finally, it would seem that there was a general need connected with the period, since regardless of whether Fauve paintings are present or not—it hardly matters—an identical current develops within a relatively short space of time in almost all European countries, thus confirming the existence of the Dionysiac myth forged by the Fauves.

IN FRANCE

Among the original nucleus of artists who gave birth to the movement and were represented in the rooms set aside for the Fauves, many familiar names, closely connected with the discussions and reviews of the time, deserve at least to be mentioned—Linaret, who died prematurely; Biette and Milcendeau, who have since been forgotten; Girieud, who, after a promising start, unfortunately took another path.

32. Henri Matisse. L'ASPHODÈLE. 1907.
Oil on canvas, 45 7/8 × 35″.
*Museum Folkwang, Essen*

33. Maurice de Vlaminck. STILL LIFE. 1907.
Oil on canvas, 28 3/4 × 23 5/8″.
*Staatsgalerie, Stuttgart*

34. Raoul Dufy. JEANNE AMONG THE FLOWERS. 1907.
Oil on canvas, 35 3/8 × 30 1/4″.
*Nouveau Musée des Beaux-Arts, Le Havre.*
*Gift of Mme Dufy, 1963*

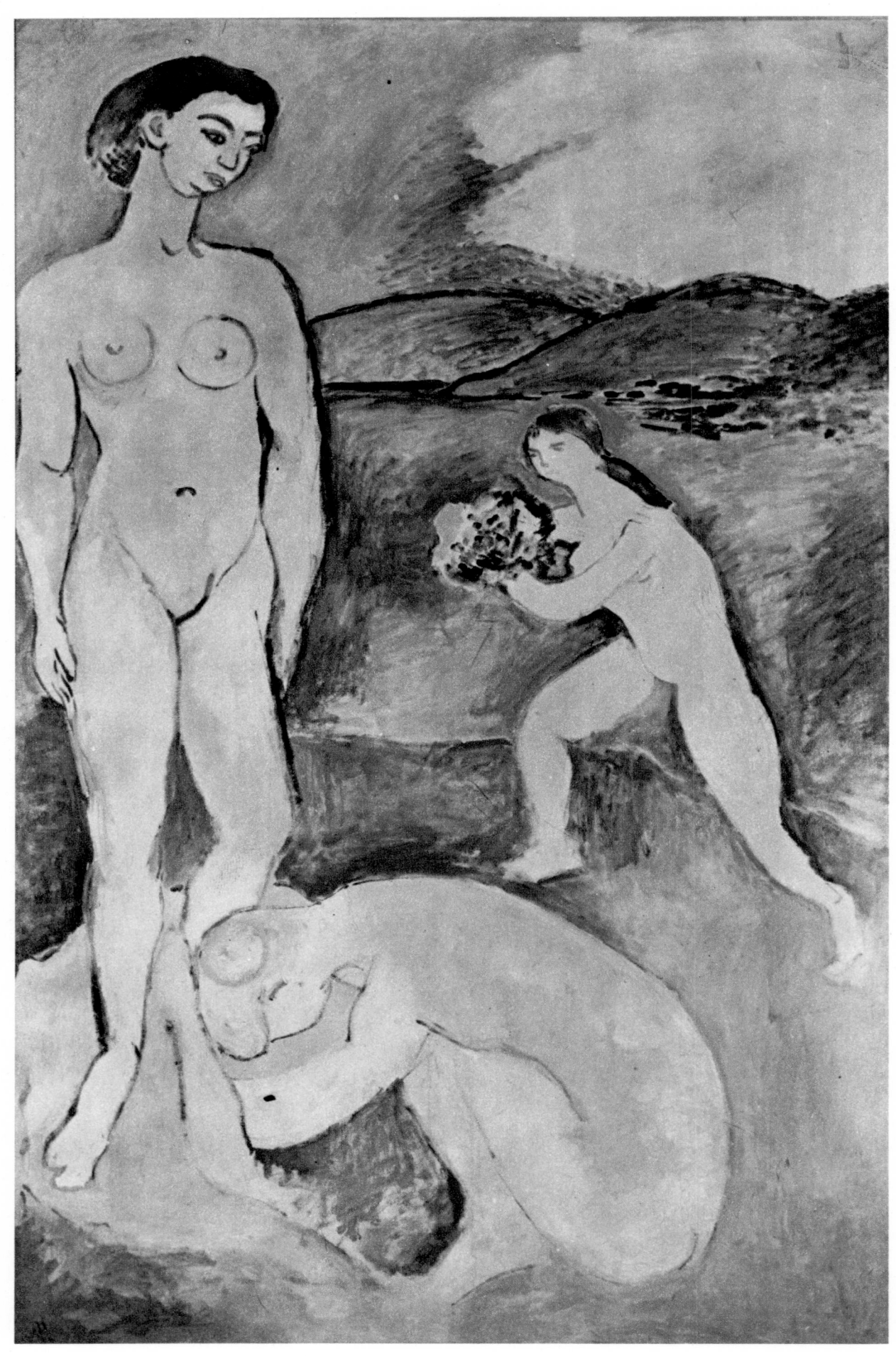

35. Henri Matisse. LE LUXE. 1906. Oil on canvas, 82 5/8 × 54 3/8". *Musée National d'Art Moderne, Paris*

The group grew so fast, however, that it is difficult to establish its exact membership. Its ranks swelled particularly between 1906 and 1907, when it reached its peak. Vauxcelles, as we have seen, ironically notes the presence of Delaunay and Bereny at the time of the Salon des Indépendants in 1907; in the same year Michel Puy remarks that "Metzinger, Le Fauconnier, Perlrott, all of them characterized by their brilliant colors, have joined the ranks." The names of many other French painters should be added, as well as those of foreign artists who were flocking to Paris. A number of future Cubists—Picasso was not among the first to make the experiment—passed in varying degrees through the intermediary stage of Fauvism. They included Villon and still more his brother Marcel Duchamp, who was closely associated with Kupka and likewise painted a number of highly expressive portraits. The same is true of Pascin, and above all of Modigliani, whose works were to hang in the Salons beside those of the Fauves.

An increasingly important group called Les Dômiers, from which Matisse was later to recruit his pupils, had formed in Montparnasse in 1905. Most of them habitually spent their days at the Café du Dôme (hence their name), had studied in Munich, and showed a lively interest in the new trends. They include Germans and Hungarians, among them Rudolf Levy, Eugen Spiro, Czóbel, Purrmann, such other friends of Pascin's as William Howard, the Americans Maurice Sterne and Max Weber, and the future critic Wilhelm Uhde, who at the time exhibited Fauve canvases in his small gallery next to the closely allied paintings of Sonia Terk. Nearly all of them embraced the current fashion and had the distinction of taking part in the Salon d'Automne as early as 1906 or 1907.

Apart from this throng of foreigners who lived in Paris for a number of years and often became deeply involved in the prevailing trend, others gave the movement temporary but nonetheless effective support. Such is the case with Kandinsky and Jawlensky, who since 1904 had regularly sent works from Munich to the Salon d'Automne, but without attracting much attention. Finally Kandinsky, wishing to enter further into the Paris milieu, settles for a year in the Rue de Binelles in Sèvres with Gabriele Münter. Here he works intensely, and the results that he exhibits in such profusion at the Salon d'Automne of 1906 (twenty pieces: paintings, woodcuts, various handicrafts made in collaboration with Gabriele), and in smaller numbers at the Indépendants of 1907, already mark a very interesting development that will assume a more definite form soon after at Murnau and will finally earn him a favorable reception at the Paris Salons, to which he remains faithful even after moving away.

Munch was similarly faithful to the Indépendants from a distance, despite the unjust scorn in which he was held by the French press. His *Garçons baignants*, to use the title in the 1904 catalogue, brilliantly anticipates his future development. Another distant contributor to the Indépendants was Cuno Amiet, who ended by joining the movement.

Two Americans then living in Paris, Patrick Henry Bruce and Alfred Maurer, exhibited regularly at the Salon d'Automne. They soon became closely associated with Fauvism, and when Matisse opened his Academy, Bruce was the *massier*, the pupil charged to collect the subscriptions and pay the expenses of the studio.

In the spring of 1908, at the instigation of his friends Sarah Stein and Purrmann, whom he had met at the Rue de Fleurus, Matisse agreed to advise a small group of artists who met in his studio in a secularized convent in the Rue de Sèvres. Later obliged to move, he took larger quarters at 35 Boulevard des Invalides, in another former convent, that of the Sacred Heart. The news of the instruction he was prepared to give soon spread, and, with the arrival of

36. Matisse's Studio in 1909

1. Straube, 2. Perlrott-Csaba,
3. Purrmann, 4. Dubreuil, 5. Rosam,
6. Guindet, 7. Revold, 8. Levy,
9. Matisse, 10. Grünewald,
11. Vollmoeller-Purrmann, 12. Wassilief,
13. Sörensen, 14. Jolin, 15. Palme,
16. Hjerten-Grünewald

38. Marcel Duchamp. PORTRAIT OF DOCTOR TRIBOUT. 1910.
Oil on canvas, 21 5/8 × 17 3/4".
*Musée des Beaux-Arts, Rouen*

37. Kees van Dongen.
PARISIAN FROM MONTMARTRE. C. 1907.
Oil on canvas, 25 5/8 × 21 1/4".
*Nouveau Musée des Beaux-Arts, Le Havre.*
*Gift of Auguste Marande, 1936*

39. Jules Pascin. PORTRAIT OF ISAAC GRÜNEWALD. 1911.
Oil on canvas, 25 5/8 × 21 1/4".
*Collection Lucy Krogh, Paris*

40. Rudolf Levy. AT THE SEINE IN PARIS. 1910. Oil on canvas, 18 1/8 × 21 5/8″. *Wilhelm-Lehmbruck-Museum der Stadt, Duisburg*

a new academic year in October, the rush of candidates forced him to organize a regular school with Purrmann as director.

The enthusiasm was entirely justified, for Matisse was then at the height of his fame. In the course of the year he exhibited watercolors and prints at the Stieglitz Gallery in New York, presented a total of thirty paintings, sculptures, and drawings at the Salon d'Automne—a rather unusual privilege—and finally organized a show of paintings at the Cassirer Gallery in Berlin. At the same time he lucidly stated his position in *Notes d'un peintre*, published in *La Grande Revue* of December 25, 1908, and soon translated into German in *Kunst und Künstler*, and into Russian in *Zolotoye Runo* (Golden Fleece), with a list of his works and an article by Mercereau pointing out his influence.

The expressiveness that he seeks, above all else, in the arrangement of the picture, through the composition and the drawing, by abandoning the literal representation of movement; the state of intensified sensation, the living harmony of color to which he aspires; the expressive quality of colors to which he is so sensitive; the desire to express, especially through the figure, the almost religious feeling that he has for life; the balanced, pure, and serene art of which he dreams, without preconceived notions of style—these, in his own terms, form the substance of the profession of faith which he drew up and which he tried to impart to his pupils during the weekly lessons. At the end of three years of sometimes unrewarded effort, tired and wishing to have more time to work and travel, he closes the Academy, of which Isaac Grünewald had become the *massier*.

41. Oskar Moll. CÔTE D'AZUR. 1912–13. Oil on canvas, 29 1/2 × 39 3/4". *Städtisches Museum, Trier*

42. Franz Nölken. WOMEN BATHING. C. 1912. Oil on canvas, 23 1/4 × 32 1/4".
*Collection Dr. Helene Gropp, Hamburg*

43. Walter Rosam. VIEW OF THE SEINE. 1912. Oil on canvas, 19 5/8 × 25 1/4″.
*Collection Lilo Streiff, Zurich*

It is true that only some of the 120 students who frequented the studio on the Boulevard des Invalides until 1911 were converted to the song of life and color that Matisse tried to convey to them with his usual proselytizing ardor. But they swelled the ranks of those who were spreading and defending the spirit of Fauvism throughout the world. Among all these foreigners the Germans—who already formed a majority in the initial group with Purrmann, Oskar and Greta Moll, soon followed by Levy and most of the Dômiers—played a role whose importance has often been underestimated because some, including Franz Nölken and Walter A. Rosam, were killed during the war, while others were to be eliminated by the Nazis. Scandinavians also were well represented with Jean Heiberg and Carl Palme, who were present from the start and introduced their compatriots. Heiberg brought in the Norwegians Axel Revold and Henrik Sörensen, accompanied

by the more independent Per Krohg and Halvorsen and sometimes by Karsten, who remained faithful to his temperament and came as an old friend. Through Palme came a number of Swedes who, with the exception of Grünewald, were not to be greatly influenced: Einar Jolin, Nils de Dardel, and others. There were also Hungarians, the sculptor Brummer and the painters Robert Bereny and Vilmos Perlrott-Csaba, who soon attracted attention in the Salons. The Americans of the Dôme had been joined by Arthur A. B. Frost, the Icelander Jon Stefansson, the Englishman Matthew Smith at a later stage, and several Russians and Austrians. On returning to their own countries in 1910 or 1911, nearly all these artists were to contribute to the diffusion of the new trends. Paradoxically, the French play only a minor part in these developments. Their number includes Charles de Fontenay, later killed in the war, Albert Guindet, who had first met Matisse in

39

44. Jean Heiberg. NUDE. 1912.
Oil on canvas, 51 1/8 × 38 3/8″.
*Rasmus Meyers Samlinger, Bergen*

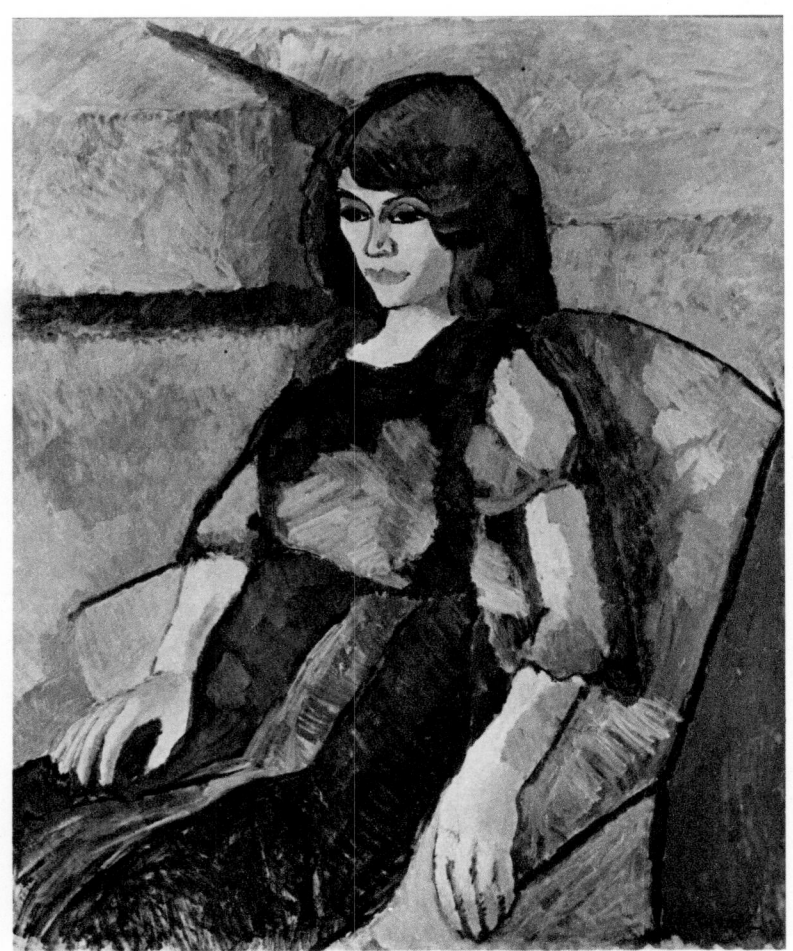

45. Axel Revold. ITALIAN WOMAN. 1914.
Oil on canvas, 36 1/4 × 29″.
*Nasjonalgalleriet, Oslo*

46. Ludvig Karsten. BEFORE THE MIRROR. 1914.
Oil on canvas, 25 5/8 × 31 7/8″.
*Nasjonalgalleriet, Oslo*

Cormon's studio and who was likewise to become fascinated by North Africa, and finally Pierre Dubreuil, who became a close friend of Pascin and Gromaire.

This general survey would be incomplete without some mention of the importance of certain foreign contributions to the cultural life of Paris. The Salon d'Automne had made a custom of inviting a foreign group every year. In 1906 the Russian contribution organized by Diaghilev presented the Moscow school in particular, with Larionov, Pavel Kuznetsov, Korovin, and Milioti, of whom the last two were to reappear at the following Salon. In 1907 it was the Belgians' turn, with well-deserved honors going to Ensor and Evenepoel; in 1908 the Finns, in 1909 the Germans, with Max Beckmann, Wilhelm Gerstel, and others. At the same time, in May and June, 1909, the Russian Ballet opened its first season at the Châtelet. The spectators were amazed and Matisse enraptured by the riot of color it presented.

Thus an active series of exchanges steadily developed among all the different countries.

## ABROAD

As it crossed frontiers and extended its influence into neighboring countries, Fauvism aroused curiosity and sympathy, and above all provided an artistic stimulus for painters who then tried to adapt it to their own needs.

Its reception in Germany is both eager and belated. The country, as we have seen, had close artistic ties with Paris despite the mutual hostility of the press. It could boast of being the first to acquire a Matisse (in 1912 by the Munich Museum), and it played an important role in the diffusion of the new aesthetic ideas. Yet, although Van Dongen was invited to Dresden in 1908, it is not until 1910 that the Fauves or Cubists are even meagerly represented at the Neue Künstler Vereinigung in Munich, and not until 1912 that they take part in any numbers in the Blaue Reiter exhibitions in the same city, in the Berlin Sezession, the impressive Sonderbund in Cologne, and the shows in Walden's Der Sturm gallery in Berlin. In 1913 they exhibit at the first German Salon d'Automne.

German Expressionism, it is true, attracts more attention. Fostered by Die Brücke, which originated in Dresden in 1906 and gained a hold in 1907, this movement, while retaining its individuality, had much in common with Fauvism. But the vehement nationalism that was long rampant on both sides of the Rhine led to persistent efforts to dissociate them and present them as rivals. In 1905 the young Expressionists are unaware of what is happening in Paris, and yet they react in the same way to the demands of the time and draw inspiration from the same sources: Van Gogh and Gauguin, whom they can admire at the

47. Vilmos Perlrott-Csaba. SELF-PORTRAIT. 1905. Oil on canvas, 21 1/4 × 18 1/2".
*Hungarian National Gallery, Budapest*

Arnold Gallery, the primitive arts, and caricature, to which they add social concerns and the visionary anxiety of Munch. Self-taught, they are more radical, like Heckel or Schmidt-Rottluff, in their revolt against tradition, more virulent in the harshness of their prints, more carried away, like Nolde, by the magic of color, more united as a result of their communal life in improvised studios and the summers spent on the Moritzburg lakes. They share, however, a need—more arbitrary in their case—for transpositions, pure color, flat areas, and compelling outlines. After the example of Cuno Amiet, who was with them for a time, they sometimes reach a certain hedonism in their more peaceful moments. This is true even of Kirchner, the leader of the group, and still more of Pechstein, who was in France in 1907 and was influenced by Cézanne. It should be noted that outside this group other artists such as Erbslöh and Kanoldt occasionally adopt this attitude as well, to say nothing of Paula Modersohn-Becker, who was so strongly influenced just before her death by the Gauguin retrospective.

A traditional European crossroads and as such easily penetrated by outside trends, Munich is to be the meeting point for West and East from the moment that Kandinsky, Gabriele Münter, and Jawlensky take over the leadership of the Neue Künstler Vereinigung in 1909 and of the Blaue Reiter at the end of 1911. They were assisted by August

48. Ernst Ludwig Kirchner. WOMAN IN HAT WITH NUDE TORSO. 1911.
Oil on canvas, 29 3/8 × 27 5/8". *Wallraf-Richartz-Museum, Cologne*

49. Max Pechstein.
LANDSCAPE WITH THREE NUDES. 1911.
Oil on canvas, 30 3/4 × 39 3/8".
*Musée National d'Art Moderne,
Paris*

Macke and Franz Marc, who had made early and frequent trips to France and had established ties with Matisse and subsequently still more with Delaunay.

The Hungarians are the first to turn from the tradition of the Munich academies and send a growing number of artists to France. Already ardent supporters of Fauvism, they will later abandon it like so many others in favor of a return to Cézannian construction. It is Czóbel, living in Paris since 1903, who prepares the way for this unexpected influx. After his success at the previous Salon d'Automne, where he had been immediately accepted by the Fauves, he returns during the summer of 1906 to sow temptation and doubt among his old friends and companions of the Nagybanya School, who then rebel against the school's outmoded teachings. Before long Paris becomes the favorite place of residence or the object of frequent visits for many Hungarian artists, who often earn for themselves the best places in the Salons. Some, like Geza Bornemisza, and above all Perlrott-Csaba, hasten to Paris and become Matisse's most assiduous pupils. Others, both older and younger, end by joining Czóbel to form "The Eight" group in 1907, which was to exhibit a number of times in 1909 and then at the Budapest National Salon in 1911 and 1912. Most of these artists—Marffy, who made a very successful debut at the Salon d'Automne in 1906 and, like Czóbel, was for a long time a member of the School of Paris; Kernstok, with his powerful lyricism; Bereny, with his rigorous style; Czigany; Orban; and Tihanyi, who finally settled permanently in Paris—exert a great influence in their country, to which they remain deeply attached. Along with the poet Ady and the historian Fülep, they help to make their compatriots aware of the problems of the modern age.

The Poles seem hardly attracted by the new movement —Wojtkiewicz, appearing at the Salon d'Automne of 1907, only slightly, Grombecki, Weiss, and somewhat more Kisling, all latecomers to Paris, and Pankiewicz, despite his age, whose art blossomed fully in Spain during the war. The Rumanians had in Pallady an excellent permanent representative in Paris, who to the end was a faithful friend of Matisse while remaining independent in his ideas. Vienna, until then the closed bastion of the Sezession, opens up slightly to the Impressionists and Post-Impressionists in 1903, and beginning in 1908 is the scene of impetuous attempts at liberation under the determined leadership of Richard Gerstl and Egon Schiele, which soon lead to the triumph of Expressionism and Kokoschka. But it is only in Prague that every effort is made to achieve total emancipation. Full and fruitful exchanges are established with Paris, which, no doubt thanks to Mercereau, sends to the 1907 exhibition of the Mánes Art Society a complete panorama of late nineteenth-century art and in 1910 a selection of 122 paintings, most of them Fauvist. Czech painters were by then already involved in the movement, following the ex-

50. Alexej von Jawlensky. NIKITA. 1910. Oil on cardboard, 33 7/8 × 29 1/8". *Städtisches Museum, Wiesbaden*

51. August Macke. PORTRAIT OF THE ARTIST'S WIFE. C. 1911. Oil on canvas, 25 1/4 × 20 7/8". *Musée National d'Art Moderne, Paris*

52. Odön Marffy. NUDE. 1910.
Oil on canvas, 23 1/4 × 17 3/4″.
*Private collection, Hungary*

53. Egon Schiele.
PORTRAIT OF A WOMAN IN A BLACK HAT. 1909.
Oil on canvas, 39 3/8 × 39 1/4″.
*Georg Waechter Memorial Foundation,
Geneva*

ample of Kupka, a resident of Paris since 1895. Filla, another of their leaders and a member of "The Eight" group, is a frequent visitor to Paris at this time, and on his return communicates his zeal for experimentation to Procházka. Prucha, who works independently, and Spála, who joins the group in 1911 and goes to Paris, have early evolved in a similar direction toward a truly instinctive Fauvism which is soon to grow more disciplined.

The best evidence of this ancestral background linked with folklore is to be found in Yugoslavia with Jakopic, and the almost unique case of Nadezda Petrovic, who although trained in Munich expresses herself with a strong, impetuous touch long before going to Paris in 1910. There she acquires an even greater richness of color, thereby opening the way for the whole artistic future of her country.

In Russia, interest in the Fauves is aroused very early by the World of Art exhibitions, and develops rapidly through contacts with Paris and the purchases of collectors. The presence of about a hundred works by the Fauves and their immediate predecessors at the Salon of the Golden Fleece in 1908 and of a smaller number in 1909, combined with Mercereau's articles, encourages Russian artists, several of whom have already gone to Paris. Older painters such as Korovin, and the younger generation—Pavel Kuznetsov, strongly influenced by the Gauguin retrospective in 1906, Sarian, Milioti, and Sapunov—paint in a free and expansive style, using brilliant colors, and are intensely active in every artistic field. They are joined by Larionov, who exhibits his glowing *Bathers at Sunset* (fig. 58) at the Golden Fleece in 1908, and by Goncharova, Malevich, and Konchalovsky, who are soon to tend toward dynamism and the "Knave of Diamonds" group.

With the exception of Scandinavia, whose artists, already deeply committed, were later to move toward a monumental art, the countries closer at hand were much less affected by the movement. The large Post-Impressionist and Fauve exhibition held in London in 1910 seems to have had little impact, the only important link being established by Smith. In Switzerland, participation is limited but steady, Cuno Amiet sometimes prompting his faithful friend Giacometti to freer expression, while Von Tscharner occasionally attends the Matisse Academy, and during the summer of 1912 even goes to Hungary to seek inspiration at Nagybanya before returning to avail himself of the atmosphere of Paris. Although Italy was now given over to the international ascendance of Futurism, Boccioni had earlier made a brief incursion into Fauvism, brilliantly represented by Viani and Rossi. The first, during his various Parisian stays between 1907 and 1909, becomes closely associated with the Germans Nolde and Heckel, and the turbulent expressiveness of his work, particularly his prints, reveals their growing influence. Rossi, who goes to Paris in 1907 with the sculptor Arturo Martini, is gradually won over by the calm radiance of color, derived chiefly

54. Emil Filla. THE CHILDREN IN THE GARDEN. 1910. Oil on canvas, 23 5/8 × 37″. *National Gallery, Prague*

55. Antonin Procházka. THE CIRCUS. 1906–7. Oil on canvas, 18 3/4 × 25 5/8″. *National Gallery, Prague*

56. Friedrich Prucha.
BEECH FOREST. 1911.
Oil on canvas,
33 1/8 × 37 5/8″.
*National Gallery,
Prague*

from Gauguin, which he then preaches to the members of the "happy colony" on Burano.

Well before the Kunstkring exhibitions of international modernism in Amsterdam in 1911, two artists had brought back from their frequent trips to Paris and through their close friendship with Van Dongen the stimulus that was needed, even in these parts where Van Gogh was honored. In 1905 Toorop, always in search of a new idiom, and in the next year Sluyters, with a force of conviction that carried Mondrian with him, rallied temporarily to Fauvism, but both abandoned it two years later in favor of Luminism and experiments in construction.

In Belgium the spread of Fauvism was particularly favored by the work of Evenepoel, whose death was a sad blow, and by the Libre Esthétique exhibitions in Brussels, which presented a complete panorama of Fauvism in two successive series in 1906 and 1907. Yet Belgium was the last country to move toward Fauvism, and it did so with a reticence strongly emphasized by Wouters. In 1912 the Giroux Gallery began to reveal a movement led by the admirable Wouters, which in fact focused its attention as much on Ensor as on Paris. Schirren, the senior member of the group, was turning in 1906 to pure color in his paintings, especially his watercolors, but like Wouters he was more attracted by sculpture. He was to continue in this quiet, more restrained artistic tradition with Deroy, Paerels, and De Kat until after the war.

57. Nadezda Petrovic. SELF-PORTRAIT. 1907.
Oil on canvas, 25 5/8 × 19 1/4".
*National Museum, Belgrade*

58. Michel Larionov.
BATHERS AT SUNSET.
1903–8.
Oil on canvas,
26 1/4 × 37 3/8".
*Private collection,
Paris*

59. Henri Evenepoel. SUNDAY PROMENADE AT SAINT-CLOUD. 1899.
Oil on canvas, 74 3/4 × 118 1/8″.
*Musée des Beaux-Arts, Liège*

At the end of this odyssey are we to conclude that Fauvism, whose historical role has ended, was nothing in France or the rest of the world but a brief flare-up soon extinguished or reabsorbed by the Cézanne tradition, Cubism, and the various recalls to order that took place before 1914? This would badly underestimate the potential forces which it held in reserve and would continue to release in many countries.

To return, for brevity's sake, to the movement's country of origin, it is true that the war, which annihilated and disrupted so many efforts, would seem to have dealt it a deathblow by trampling underfoot and desecrating everything that had formed the basis of its existence: a spontaneous joy of life, a serene rationalism, a warm belief in man. Even those who, like Matisse and Van Dongen, interpreted and explained Fauvism to the best of their abilities until the outbreak of the war seemed rather discouraged, changed, and ready to give in to the fallacious arguments of the critics who were exhorting them to return to healthy traditions.

Yet in them and the others, Manguin and Dufy particularly, the fire continues to smolder until it finally flares up again. From 1927 onward Fauvism is gradually reborn

from its ashes, resumes its place in the struggle and soon reaffirms, through the words and works of Matisse, the virtues of a necessary and constant revolt against convention. For Pignon, Estève, Manessier, Singier, Schneider, Vasarely, and many others, it becomes directly or indirectly the leaven that will quicken a whole generation before and after World War II. Grievously afflicted by events and his inexorable illness, even at death's door Matisse remains indomitable, and by his example his old friends and colleagues, from Camoin to Valtat, from Derain to Marquet, also regain at certain moments that vibrant sense of life and color that illuminated their youth.

During the dark war years I earnestly considered, in my first book on Fauvism, whether the movement should be regarded as the close of a cycle, an irrevocable conclusion to the efforts of the preceding century, or on the contrary as the beginning of a promising renewal. I confess that I found it hard then, despite many obvious signs given by both older and younger painters, to conceive of an art capable of soon offering these eagerly awaited rediscoveries.

48

In historical perspective the evolution of painting has itself provided the answer. The Fauves opened a new era and most certainly gave rise to a powerful and stimulating movement that has not ceased to disrupt outmoded habits and provide inspiration for the future.

Color has invaded our epoch, triumphing almost everywhere. We are inundated and obsessed by it. If we tolerate and even favor its universal presence, it is surely because it helps us to escape from our closed world with its steadily growing tensions and forebodings. Its Dionysiac virtues spread the illusion of youth and offer the solace of an overflowing vitality.

The magic of color leads us, through its inherent impetuosity and dynamism, to a better understanding of our times, by giving us access to the universal and popular language that alone can fulfill our present needs.

The quickening influence of Fauvism is still enriching and broadening artistic life.

60. Ferdinand Schirren. ON THE SAND. C. 1906. Oil on canvas pasted on cardboard, 10 5/8 × 12 7/8".
*Private collection, Brussels*

# DRAWINGS, WATERCOLORS,
## AND PRINTS

Unlike the German artists of Die Brücke or Der Blaue Reiter, who from the beginning strove to publish regularly their amazingly unified albums of plates, and to organize exhibitions of prints and drawings, the Fauves, with the possible exception of Matisse, were hardly concerned with the graphic arts in their own right, independently of painting, and attributed only minor importance to them.

Whereas the Dresden Expressionists worked in collaboration, individualism was the rule among the French. The only attempt at collective work was the one successfully undertaken by the ceramist Metthey for the Salon d'Automne of 1907, where each artist offered his individual collaboration and affirmed his personality in what was predominantly an exercise in painting.

Throughout the Fauves' work, however, there runs a certain family resemblance, discernible in the bold, synthetic appearance of line that characterizes the style of a period in which Japanese art, caricatures, and posters exercised a great fascination. This kinship would have become more obvious if the Fauves, like the Nabis, had used lithography, but no publisher—not even Vollard—approached them when the movement was at its height, and it was not until the period between the two wars and in some cases even later that they were able to show their potentialities and their undeniable talent in this technique as well as in etching. Woodcuts were in a better position, for they had been popular since Gauguin, Munch, and many others had revealed their rich possibilities, and Vallotton had followed their example. Several of the Fauves were attracted by this medium and made use of it—for example, Valtat as early as 1898—or took pleasure in experimenting with it. Here again, however, the commissions arrived belatedly, when Fauvism had disappeared and its former adherents had adopted a more rigorous style that moreover gave better results. The woodcuts that Kahnweiler commissioned from

Derain in 1909 to illustrate Apollinaire's *L'Enchanteur pourrissant* and in 1911 for Max Jacob's *Les Oeuvres de Frère Matorel* anticipate other, later successes, particularly the *Pantagruel* of 1945 that was to be the fitting conclusion to his work; Dufy's illustrations of 1911 for Apollinaire's *Le Bestiaire* are an excellent preamble to his later work for Poiret; then there are Braque's *Le Piège de Méduse* of 1921 and Vlaminck's various woodcuts, also from the postwar period. But this unfortunately brings us far from the Fauve period, to which it is time to return.

Marquet was unquestionably the most gifted of all, a true virtuoso whom his friends dubbed "our Hokusai." A dedicated draftsman, he started very early to note down in pencil, or with a brush like the Japanese, silhouettes, scenes, crowds caught on the spot. He is a past master at rendering the flow of movement and his intelligence and sharpness of observation are extraordinary. His highly condensed, elliptical way of depicting a whole scene is both supremely elegant and profoundly human. More than with any of the others, one can only feel sorry that his gifts as an illustrator were not exploited earlier.

Although in the beginning Matisse often worked with his friend Marquet and used the same thick line with equal skill, his manner and aims are very different. He introduces more violence and sensuality into his simplifications. His passion for drawing is more an exercise through which he conducts parallel experiments involving light, expression, and space in concert with his ceaseless research on form, color, and volume and with his work in sculpture and engraving. Yet line is for him an end, an absolute, a creation in itself, and he was almost the only artist to reserve an important place for his graphic work in the Salons and in his exhibitions. In 1908 he held a show at the Stieglitz Gallery in New York consisting exclusively of engravings, lithographs, watercolors, and drawings. He gradually

developed the sustained, melodic line which is his special characteristic, and which he used to trace his wonderful, slender arabesques on copper, stone, or linoleum when, after 1932, he received an increasing number of commissions for illustrations.

Derain's skill is early apparent in the drawings that he produced in 1902 and 1903, while still in the army, for his friend Vlaminck's books. A notebook dating from the Fauve years shows a marvelous verve and assurance, but, overtaken by qualms, he already combines his bold improvisations with traditional elements that he will soon introduce into his first etchings.

The graphic style of most of the other Fauves early reflects the personal ideas to which they will remain faithful. Valtat gives expression to his youthful and ebullient vitality with a happy spontaneity. Friesz feels the need for self-expression combined with a desire for accurate observation and a certain restraint, and this will lead him in the postwar period to show a frequent preference for the waxy, flexible lithographic crayon in his illustrations. Dufy acquires an early mastery of the light, cursive, and playful touch that is a prelude to his later dynamic shorthand and by which he will achieve many striking effects, particularly in his etchings, lithographs, and ceramics. Manguin's remarkable drawings and watercolors, by which he always set great store, betray the demanding will, the tenacious effort that he manages to conceal under the guise of a happy, steadily evolving serenity. Firmly entrenched in his convictions and certitudes, the prolific Vlaminck expends himself in a craftsmanship that he will later abundantly develop.

Finally, Van Dongen is the only one who, even in his many illustrations, long maintains a difference, or, so to speak, a distance between painting and drawing. Having begun as a draftsman, he feels more at home, more free to express himself in this medium, to which he gives a satirical or biting turn as he sees fit. He gives color free rein in his watercolors before he ventures to do so in his canvases. Taking up the larger medium, he uses his painting to pour scorn on a large part of humanity, thus revealing his true predilection.

61. André Derain. CHILDREN'S GAMES. C. 1903.
Brush with India ink, 11 3/4 × 7 7/8″.
*Musée National d'Art Moderne, Paris*

62. André Derain. STREET SCENE. 1905.
Pencil, 11 3/4 × 7 7/8″.
*Musée National d'Art Moderne, Paris*

63. André Derain. NOTES ON A SETTING SUN. 1905. Watercolor, 11 3/4 × 7 7/8″. *Musée National d'Art Moderne, Paris*

64. André Derain.
THE BRIDGE AT CHATOU. 1905.
Watercolor, 18 1/2 × 22 1/2".
*Private collection, Paris*

65. André Derain.
BATHERS. 1907.
Decorated porcelain plate,
diameter 9".
*Collection Samuel Josefowitz, Lausanne*

66. Raoul Dufy. BREAKWATER. C. 1910–12.
Charcoal, 18 1/2 × 22 1/2″.
*Nouveau Musée des Beaux-Arts, Le Havre*

67. Othon Friesz.
STUDY FOR PORTRAIT OF FERNAND FLEURET. 1907.
Colored pencil on beige paper, 14 1/8 × 9″.
*Musée National d'Art Moderne, Paris*

68. Henri Manguin. NUDE WITH BLACK STOCKINGS. 1903.
Brush with India ink, 11 × 8 5/8″.
*Galerie de Paris, Paris*

69. Henri Manguin. BATHERS. 1905.
Watercolor, 13 3/4 × 17 3/4″.
*Galerie de Paris, Paris*

70. Albert Marquet. SILHOUETTE OF JACQUELINE MARVAL. c. 1901. Pencil, 11 3/8 × 8 5/8″.
*Musée de Peinture et de Sculpture, Grenoble*

71. Albert Marquet. WOMAN WITH BASKET. 1904.
Brush with India ink, 8 3/8 × 6 1/4″.
*Musée des Beaux-Arts, Bordeaux*

72. Albert Marquet. MAN STANDING.
c. 1905.
India ink on cream-colored paper,
13 × 8″.
*Musée National d'Art Moderne,
Paris*

73. Albert Marquet.
CARNIVAL AT COLLIOURE. 1908.
Brush with India ink,
5 1/8 × 7 1/8″.
*Musée des Beaux-Arts,
Bordeaux*

74. Henri Matisse. NUDE SEEN FROM THE BACK. 1903.
Pen and ink, 10 5/8 × 7 7/8".
*Musée de Peinture et de Sculpture, Grenoble*

75. Henri Matisse. NUDE. C. 1908.
Black lead, 12 1/4 × 9".
*Musée de Peinture et de Sculpture,*
*Grenoble*

76. Henri Matisse. DANCE. 1909. Charcoal, 18 7/8 × 25 5/8″. *Musée de Peinture et de Sculpture, Grenoble. Gift of Agutte-Sembat*

77. Jan Toorop. PORTRAIT OF MME LUCIE VAN DAM VAN ISSELT. 1905.
Oil on canvas, 27 3/8 × 25 1/4″. *Gemeentemuseum, The Hague*

78. Louis Valtat.
SPANISH SILHOUETTES. 1894.
India ink, 6 1/4 × 9 7/8″.
*Private collection, Switzerland*

79. Kees van Dongen. THE PRODUCE VENDOR. C. 1902.
Charcoal, 11 3/4 × 17 3/4″.
*Private collection, Paris*

80. Kees van Dongen.
NUDE WITH CORSET. C. 1904.
Watercolor, 17 3/4 × 21 5/8″.
*Private collection, Paris*

81. Kees van Dongen. NUDE. 1907.
Decorated porcelain plate,
diameter 9″.
*Collection Samuel Josefowitz,
Lausanne*

82. Maurice de Vlaminck. A VILLAGE STREET. C. 1907. Brush with India ink, 9 3/4 × 12 5/8″. *Private collection, Paris*

# CHRONOLOGY

---

1895–98    A friendly nucleus forms in Gustave Moreau's studio, Matisse and Marquet, already good friends, being joined by Evenepoel, Manguin, and Camoin.

Beginning of 1898, Matisse goes to Corsica. Death of Moreau in April. Matisse and Marquet embark on Pre-Fauvism. Friesz enters Bonnat's studio.

1898–1901    In Carrière's studio, Matisse has a strong influence on Biette, Derain, Chabaud, Karsten, and Puy.

Late 1900, Derain and Vlaminck meet and work together at Chatou. Dufy at the Ecole des Beaux-Arts. Arrival of Braque in Paris.

1901, Matisse and Marquet exhibit at the Indépendants, where Valtat had preceded them. In the following years they are joined by Manguin, Camoin, Van Dongen, and others, Van Dongen having settled permanently in Paris at the end of 1899.

1901, at the Van Gogh retrospective, Derain introduces Vlaminck to Matisse.

1902    First group exhibitions at Berthe Weill's. In Munich, Kandinsky presides over "Die Phalanx."

1903    Matisse and Marquet exhibit at the new Salon d'Automne, where they are subsequently joined by Valtat, Camoin, Manguin, and others. Death of Gauguin.

Works of Cézanne, Gauguin, and Van Gogh at the Berlin Sezession.

The Post-Impressionists at the Vienna Sezession.

1904    In April, group show of the works of Camoin, Manguin, Marquet, Matisse, and Puy at Berthe Weill's. Matisse has an exhibition at Vollard's in June and spends the summer with Signac at Saint-Tropez, where he experiments with Neo-Impressionism. Vollard, who had signed a contract with Valtat in 1900, organizes a show of his work; exhibits Van Dongen in November.

Having finished his military service, Derain again works with Vlaminck.

1905    Seurat and Van Gogh retrospectives at the Indépendants. The new painting begins to take hold, and Matisse's Pointillist canvas causes a sensation, prompting many of his friends to go in their turn to Saint-Tropez during the summer.

In Dresden, formation of the Brücke association by the architecture students Heckel, Kirchner, Bleyl, and Schmidt-Rottluff; Van Gogh exhibition.

Jawlensky in Brittany and Provence.

Matisse and Derain are filled with enthusiasm at Collioure, where they are able to admire Gauguin's works at Daniel de Monfreid's.

The works painted at Saint-Tropez and Collioure, glowing with color, are assembled with those of Vlaminck, Van Dongen, Czóbel, at the Salon d'Automne in one room, which Vauxcelles christens the Fauves' den. In late October Berthe Weill opens a show for the whole group in her gallery, and Prath & Magnier follow suit, after first holding a Friesz exhibition. Van Dongen shows in November at the Druet Gallery. Jawlensky

and Kandinsky take part in the Salon d'Automne.

1906    Matisse moves to the Rue de Sèvres, to the ex-convent of Les Oiseaux. Here he paints *Joy of Life*, which causes a stir at the Indépendants and establishes his authority over the whole group. Success of his large exhibition at Druet's in March. Trip to Biskra. Braque shows for the first time at the Indépendants and goes to Antwerp with Friesz. Derain in London.

Brilliant success of the Fauves' room, with the addition of Friesz, Dufy, Marinot, and others, at the Salon d'Automne, which also pays ample tribute to Gauguin and offers a display of Russian art. Kandinsky and Gabriele Münter settle for a year in Sèvres and exhibit at the Salon d'Automne. Arrival of many foreign artists in Paris.

The Berlin Sezession invites Valtat.

In Dresden, Pechstein, Nolde, and shortly thereafter Cuno Amiet and Axel Gallen-Kallela, join Die Brücke; the group publishes its first album of prints, and organizes an exhibition of paintings in the autumn and another of graphic works in the winter.

Works of the Neo-Impressionists and Gauguin exhibited at the Arnold Gallery.

1907    At the Indépendants the Fauves—among whom the critics class the newcomers Bereny, Delaunay, and Metzinger—are the center of attention; they are even more so at the Salon d'Automne, where Braque has joined them, and already their works are distributed in several rooms.

In March and November, exhibition of the whole group at Berthe Weill's; another exhibition at the Blot Gallery.

The Fauves take part, as in the previous year, in the Salon de la Libre Esthétique in Brussels. Marquet and Friesz have one-man shows at Druet's, and Camoin and Van Dongen at Kahnweiler's. In Dresden, Die Brücke exhibits at the Richter Gallery.

Matisse, who has started to teach a few pupils, is obliged by their growing numbers to move to the Boulevard des Invalides in the fall and to organize a real academy.

1908    Several of the Fauves do not take part in the Indépendants and the critics congratulate those who show a change of approach. Their group is fully represented, however, at Le Havre, Toulouse, and abroad—particularly at the Golden Fleece Salon in Moscow.

Total dispersal at the Salon d'Automne, where Matisse presents a collection of his works. He has a show of graphics in New York, and of paintings in Berlin; in December he publishes *Notes d'un peintre*.

Van Dongen, who has a show at Bernheim's, is invited to exhibit with Die Brücke; Pechstein visits France. Czóbel exhibits at Berthe Weill's, Braque at Kahnweiler's.

1909    Another, smaller exhibition of the Fauves at the Golden Fleece Salon in Moscow.

Kandinsky and his friends found the Munich Neue Künstler Vereinigung, which exhibits the works of several French artists the following year: Braque, Derain, Van Dongen, and others.

The Russian Ballet performs in Paris.

A group of German painters is invited to the Salon d'Automne.

1910    Large Matisse retrospective at the Bernheim-Jeune Gallery and a second exhibition of graphics in New York.

The Fauves are represented at the Mánes Society in Prague.

Fourth album and new exhibition of Die Brücke in Dresden.

Matisse and Marquet in Munich.

1911    French artists take part in the Berlin Sezession.

In Munich, a group of artists answers the protest by the painter Winnen against the invasion of French art.

A number of French artists are represented at the Blaue Reiter exhibition in December, and in the album subsequently published.

1912    The former Fauves are well represented at the Berlin Sezession, and still more so at the Sonderbund in Cologne, the Grafton Gallery in London, at St. Petersburg, and Zurich.

1913    Exhibition in Berlin of the works of Matisse and Friesz.

Important French contribution at the Armory Show in New York.

# COLORPLATES

PAUL GAUGUIN (1848–1903)
Painted in 1894
*The Day of the God (Mahana no Atua)*
Oil on canvas, 27 3/8 × 35 3/8"
The Art Institute of Chicago

Many artists set a fundamental example for the Fauves in their rejection of outmoded traditions and their enthusiastic discovery of the impact of color: Delacroix, Monticelli, on occasion Ingres and Manet, the Impressionists and the Japanese, these latter two coming into their own at the end of the nineteenth century. In the previous generation, there were such obvious predecessors as Ensor and Munch, without there being, however, any actual contact. For some of them, Gustave Moreau was to be the most effective inspiration and guide for their youthful efforts.

Greatest of all was the attraction of Van Gogh and Cézanne, but even this cannot eclipse the overwhelming influence of Gauguin on the whole group, and particularly on Matisse to the end of his career. This influence operated on two different levels—one technical, the other spiritual and aesthetic—which cannot be dissociated. This is apparent in *The Day of the God*, finished during Gauguin's stay in Paris, which sums up all his leading aspirations.

By means of subtle gradations, Gauguin's highly saturated color here achieves its greatest richness. He applies it in skillfully interwoven planes where there is a play of complementary colors. The extraordinary luminosity of the foreground brings out the predominantly ultramarine background, heightened by contrasting vermilions, yellows, and slightly tinted whites. The alternating bands of color, enclosed by their sinuous outlines, admirably define a suggested space without detracting from the effectiveness of the flat areas boldly introduced from the bottom upward to unify and harmonize the whole composition.

The deliberate symbolism and the disturbing presence of the tutelary god vanish before the enchantment of a primitive life in which the golden hue of naked bodies, music, and dance are mingled in a peaceful spectacle of everyday existence that vividly evokes the original concept of paradise.

Such were the rejuvenating examples that inspired the Fauves. Matisse especially, who in 1905 saw Gauguin's last paintings at Daniel de Monfreid's at Collioure, was spellbound, and henceforth exploited this eloquence of color while often indulging in the same exotic dreams. He never ceased to reflect this image of an eternal paradise in his interiors, with their luxuriant plants, and in his dreams of flower maidens. In 1930 he made the journey to Tahiti, and not long before his death he vividly re-created in tapestry his dazzled memories of the South Sea lagoons.

# ARMAND SÉGUIN (1869–1904)

Painted in 1894
*The Two Cottages*
Oil on canvas, 23 5/8 × 35 7/8"
Collection Samuel Josefowitz, Lausanne

The younger generations had little opportunity to see Gauguin's work during his lifetime except for his exhibition in November, 1893, at Durand-Ruel, and that of 1903 at Vollard's. It is therefore not surprising that the large retrospective at the Salon d'Automne in 1906 should have been such a dazzling revelation to so many artists, particularly those from abroad. Yet Gauguin's influence becomes apparent at an early date, and during the last decade of the nineteenth century many painters undertake to transmit his precepts with varying degrees of understanding.

The first to be exposed to his influence and to publicize his merits are the future Nabis. As early as November, 1888, even before they have formed a group, Sérusier brings back from his stay at Pont-Aven his famous *Talisman*, painted under the master's direction at the Bois d'Amour, and communicates his enthusiasm to his young companions at the Académie Julian. Sérusier was later to return to Brittany with Jan Verkade and Mogens Ballin, to work with Gauguin before and after his voyage to Tahiti. In 1895 his paintings still reflect this influence, which he will soon throw off. The only member of the group who long remains faithful to Gauguin is Maillol, the quality of whose paintings has too often been neglected, as is apparent from *The Wave* of 1898 (Musée du Petit Palais, Paris), with its stylized flat areas and rich blues.

Very few of the Pont-Aven group—as the artists who had gathered round Gauguin were called—were to have a consistent influence on the younger painters, for some of them, like Emile Bernard, changed their orientation, while others, such as Charles Laval or Meyer de Haan, disappeared from the scene. Schuffenecker and Filiger continued to exhibit at the Salons, but the first always with restraint and the second enclosed in a narrow symbolism. Three artists were finally to play a more important role: the Swiss Cuno Amiet, who later will enjoy great popularity in his own country, the Irishman O'Connor, who accompanies Gauguin in 1894 and later appears regularly at the Salon d'Automne as one of his rather distant followers, and Armand Séguin. Having moved into the Pension Gloanec in 1890, Séguin introduced his two friends to this milieu. In 1895 he had a one-man show at Le Barc de Boutteville that included this painting. As he explained in his introduction, the picture is to some extent influenced by Gauguin but is also significantly related to the developments of the moment. The warmth of the colors, the accentuation of the outlines, the sweeping arabesques seem by their very freedom to suggest the quest on which the Fauves were to embark a few years later. Séguin's early Pointillist technique also serves as a reminder that this movement always aroused lively interest among the younger artists and provided an indispensable springboard for their final development.

# LOUIS VALTAT (1869–1952)

Painted in 1894
*Nude in a Garden*
Oil on canvas, 17 3/8 × 21 5/8"
Collection Dr. Jean Valtat, Paris

Valtat was born on August 8, 1869, of a family of shipowners, and when his parents settled in Versailles in 1880 he started his classical studies at the Lycée Hoche. His parents strongly encouraged his early artistic tendencies, and in 1888 he went to study under Dupré at the Académie Julian, where he met the future Nabis. He then attended the Ecole des Beaux-Arts for a time and was awarded a medal there.

In 1889 he begins to exhibit at the Indépendants, and the following year takes a studio of his own in the Rue de la Glacière, where he does vigorous renderings of street scenes and figures, and goes boldly beyond Impressionism and Neo-Impressionism, although their combined influence is at times still apparent.

In October, 1894, he travels to England, and then spends the whole winter at Banyuls and Collioure, where he makes friends with Maillol, and later goes to Llansa in Spain with Daniel de Monfreid. These two artists, particularly the second, already in constant touch with Gauguin, have a deep influence on the young man, as do, in the same place ten years later, Matisse and Derain.

*Nude in a Garden*, probably executed at this time, with its splashes of pink and orange, its graduated luminous greens, its powerful outlines, the raised horizon, and even the curiously coiled figure, clearly suggests a sudden and ardent admiration for Gauguin, about whom Valtat had already heard a great deal from Sérusier. Its joyful brilliance of color anticipates by a number of years the course that the Fauves were to follow.

Too isolated in his research—he was always to remain rather aloof, suspended between two generations and two groups—he feels the need to seek companions among the Nabis. He works with Albert André and Lugné-Poë on the sets for *Le Chariot de terre-cuite*, and furnishes drawings and woodcuts for the review *L'Omnibus de Corinthe*.

His elegant series *Les Jeunes Femmes au bois*, almost Baroque in style, brings him success but distracts him from his earlier objectives. After building a house in 1899 at Anthéor, where he is henceforth to spend a part of each year, he pays frequent visits to Renoir, works with him at Manganose, and is to some extent drawn by him into a kind of Mediterranean euphoria.

He recovers himself, however, using a swift, dense, but very light touch during a trip to Venice in 1902. After staying with Signac in 1903 and again during the winter of 1904, he works with heightened vigor and color. Several of his paintings once more anticipate the birth of Fauvism. Thus at the Salon d'Automne, although his five paintings are still far from the Fauves' room, having been hung in Room XV with the works of Biette, Marinot, Jawlensky, and Kandinsky, one of his seascapes is nonetheless pilloried in *L'Illustration* along with the canvases of Matisse, Derain, and Manguin. A hostile press forcibly, but quite justifiably, included him among the Fauves.